Images of War D-Day

RARE PHOTOGRAPHS FROM WARTIME ARCHIVES

Francis Crosby

Pen & Sword

MILITARY

First published in Great Britain in 2004 by
Pen & Sword Military
an imprint of
Pen & Sword Books Ltd,
47 Church Street, Barnsley,
South Yorkshire.
S70 2AS

A CIP record for this book is available from the British Library

ISBN 1-84415-077-1

British Library Cataloguing-in-Publication Data

A CIP catalogue record for this book is available from the British
Library

The photographs in this book have been obtained and reproduced
with the kind permission of the Imperial War Museum and the
United States Military Archives. The photograph captions indicate
the source (IWM or USA) followed by the reference number.
Those marked PC were supplied by Peter Coles.

Typset in Gill Sans Light 10pt
Printed and bound CPI
Pen & Sword Books Ltd incorporates the Imprints of Pen &
Sword Aviation, Pen & Sword Maritime, Pen & Sword Military,
Wharncliffe Local History, Pen and Sword Select, Pen and Sword
Military Classics and Leo Cooper.
For a complete list of Pen & Sword titles please contact
Pen & Sword Books Limited
47 Church Street, Barnsley, South Yorkshire, S70 2AS, England
E-mail: enquiries@pen-and-sword.co.uk
Website: www.pen-and-sword.co.uk

CONTENTS

Introduction.. **4**

Part 1
Preparation... **6**

Part 2
The Landings... **18**

Part 3
Establishing the Beach-head................................. **41**

Part 4
Moving Inland.. **64**

Part 5
Sustaining the Advance.. **97**

Part of the airborne armada heading for Normandy. Vessels of the Allied invasion fleet are close to the French shore where fires can be seen burning on the beaches. 250 RAF gliders and their towing aircraft flew to the Caen district on the evening of 6 June in the largest main glider-descent of the campaign at that point. (IWM CL29)

Introduction

Had it not been for stormy weather in the Channel area, June 5 would have gone down in history as D-Day, the day that Britain and the Allies returned to France in force with the aim of liberating not only France but the rest of Europe from Nazi domination.

Although the weather was not predicted to improve dramatically, Allied 'met' experts anticipated a brief improvement on the 6th. Just as invaders through the ages have relied on the most elemental factors to improve their chances of success, Eisenhower, Supreme Allied Commander, was aware that the moon and tides would not be so favourable again for some time. With that in mind 'Ike' gave the go signal for the biggest seaborne invasion in human history.

Planning for the invasion had been underway since the Americans joined World War II and by Spring 1944, everything was in place. Almost exactly four years earlier the British Expeditionary Force had been forced back by a blistering German advance to Dunkirk. This time the Allies had to hit the Germans hard and with the element of surprise while enjoying air superiority over the invasion areas. The planners decided to attack France where the Germans were not expecting it, on the Cotentin Caen stretch of the French coast. Although it was a longer and more hazardous journey than that to the expected landing area of the Pas de Calais, the beaches of Normandy were considered more suitable and the German defences were known the be lighter.

During the first six months of 1944, the Allies concentrated naval, land, and air forces in Britain to prepare for Operation OVERLORD, the assault on Hitler's Fortress Europe. Allied troops trained separately and jointly for the operation while the planners honed the plan to perfection to make maximum use of the massive force and resources at their disposal. Nine army divisions (three airborne and six infantry) from the United States, Britain and Canada trained and rehearsed their roles in the meticulously planned operation.

As D-Day dawned, while more than 5,000 ships from battleships to landing craft, headed for France, more than 1,000 transport aircraft dropped paratroopers to secure the flanks and beach exits of the assault area. Amphibious craft landed troops on five beaches along fifty miles of Normandy coast. In the eastern sector the British and Canadians landed on what were

codenamed Gold, Juno and Sword Beaches while the Americans landed on two beaches in the west, Utah and Omaha.

By the end of D-Day, the Allies had landed as many as 155,000 troops in France by sea and air, several thousand vehicles including tanks, hundreds of artillery pieces and about 4,000 tons of supplies and, astonishingly, had achieved complete surprise in doing it. Hitler's Atlantic Wall had been breached but the battle was far from over. The bridgehead had to be secured and expanded to prevent the *Wehrmacht* from driving the Allies back into the sea. As those brave men fought their way up the beaches of Normandy, their steps were the first on the road to victory in Europe. This book, featuring images from the Imperial War Museum's outstanding Photographic Archive and the United States Military Archives, is dedicated to those who fought to free the world of tyranny.

Part 1
Preparation

A woman hangs out her laundry in a south coast (possibly Southampton) garden on 5 June 1944; the road behind is full of parked vehicles and armour. Much of the south coast became a huge car park for Allied armies. (IWM CL19)

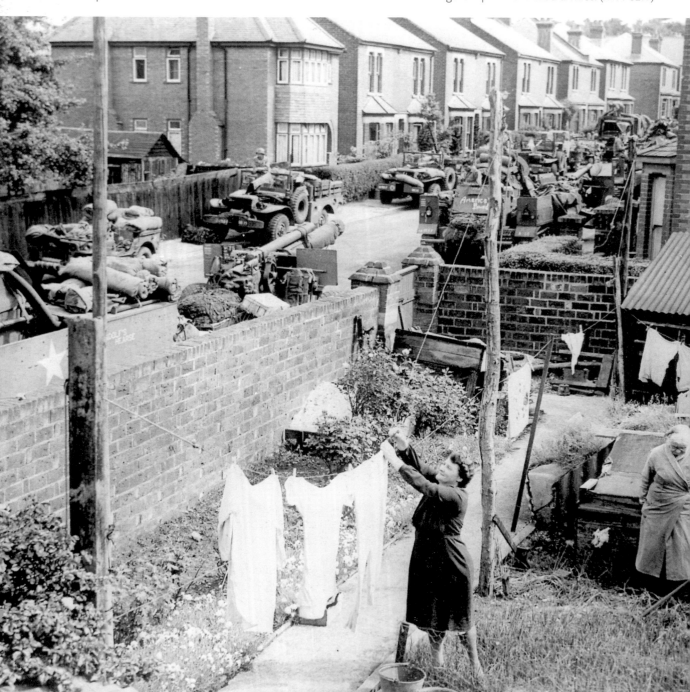

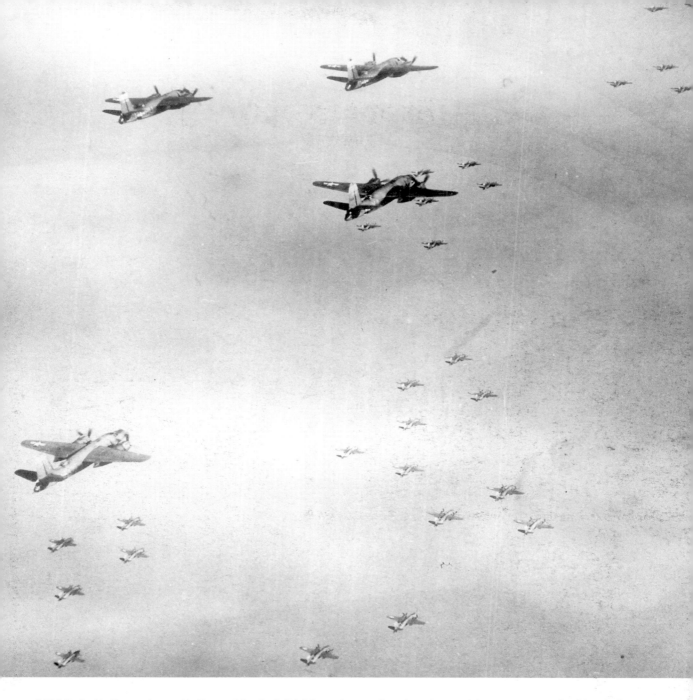

US Ninth Air Force Army Air Force, Martin B-26 Marauder medium-bombers setting out across the North Sea from UK bases on a mission against enemy E-boat pens at Ijmuiden, Holland, on 26 March 1944. This mission was part of the prelude to D-Day as the Allies tried to eliminate the German Navy and render it ineffective or at least keep it in its bases.

The later variants of the B-26 could carry a bomb load in excess of 3,000 lb and had an effective range of 1,100 miles. The aircraft was heavily armed and, by 1944, Marauders of the US 9th Air Force were returning the lowest loss rate on operational missions of any aircraft in the European theatre. (IWM EA19186)

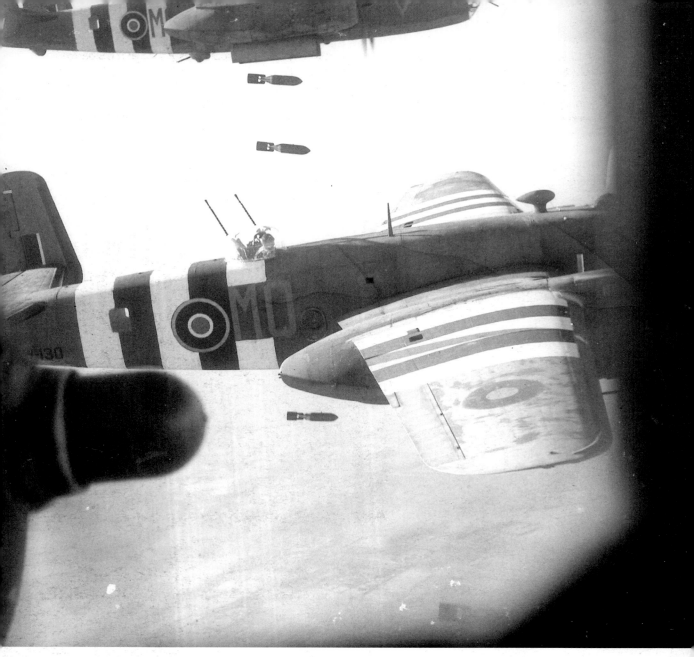

North American B-25 Mitchell IIs of No.226 Squadron RAF, 137 Wing, part of the 2nd Tactical Air Force. Note that both the aircraft pictured are in the middle of a bombing run.

The B-25 Mitchell had entered USAAF service in 1941 and was made famous by the April 1942 Doolittle raid against Tokyo from the carrier USS Hornet.

Under the Lend-Lease deal between Britain and the US, the RAF acquired over 800 examples of this robust and reliable bomber. The first entered RAF service with Nos 98 and 180 Squadrons in September 1942. From August 1943 they operated as part of the 2nd Tactical Air Force, carrying out pre-invasion attacks on targets in Northern France as well as on 'doodlebug' sites in the Pas de Calais.

Effective at both low and medium altitude, the B-25 was an excellent light bomber that was widely used in support of Allied land forces. Note the black and white Allied 'invasion' stripes which all Allied tactical aircraft carried for ease of recognition. (IWM CL107)

Douglas A-20 Havoc pictured over the Cherbourg Peninsular attacking German supply lines. Although a US design, the A-20 attack bomber was proved in combat by the British and French. On 4 July 1942, six A-20s flown by American crews of the 15th Bombardment Squadron accompanied by six flown by RAF crews, carried out a low-altitude mission against four Dutch airfields, the first US daylight bombing raid in Europe.
A-20 production ceased in September 1944 with over 7,000 being built for the US and the Allies. (IWM EA25765)

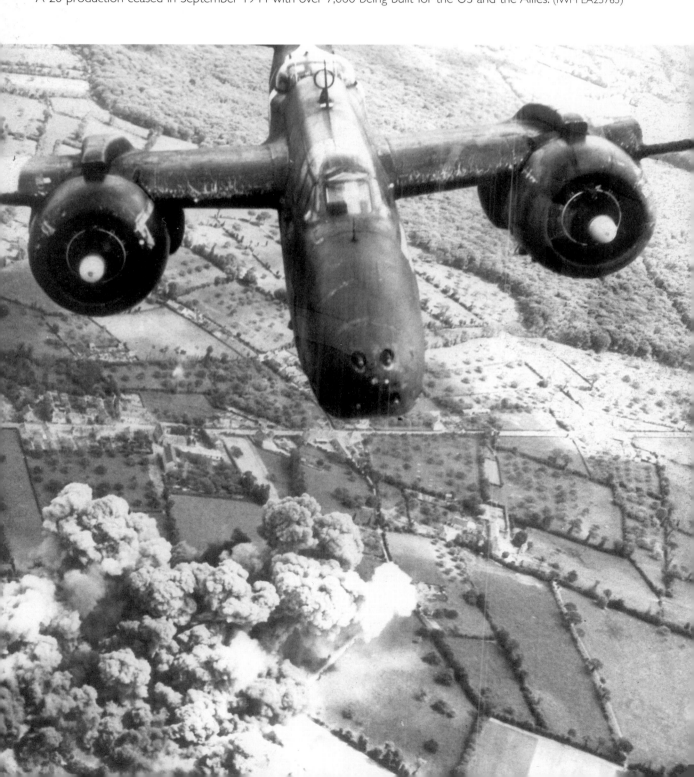

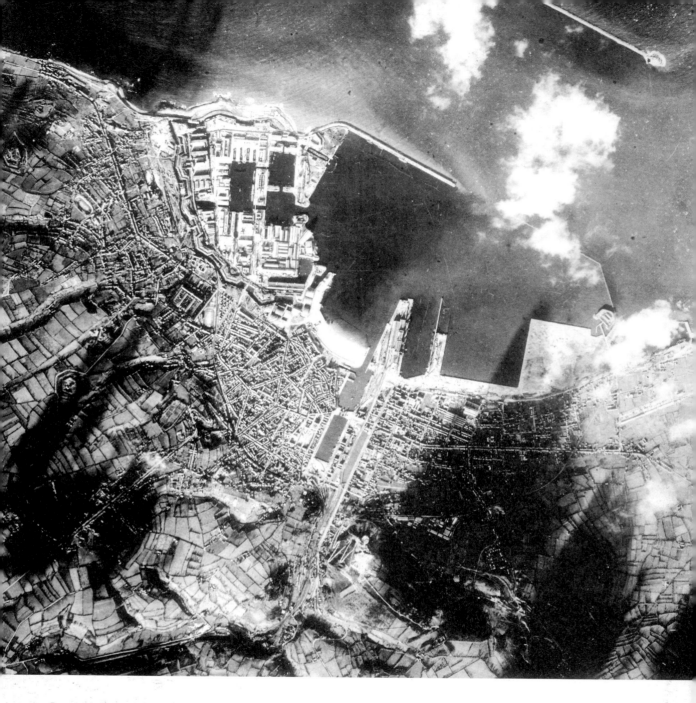

Royal Air Force reconnaissance photograph of Cherbourg. The capture of this deep-water port was essential to the success of the Allies' campaign in Normandy as the invading armies had to be kept supplied. The need for the port's capture was intensified when the American artificial Mulberry Harbour was rendered useless by Channel storms within two weeks of the D-Day landings. On 18 June 1944 US forces struck across the Cotentin Peninsula thereby cutting off Cherbourg at its tip from the rest of France. The German forces in Cherbourg surrendered but had adhered to Hitler's instructions to '...leave the enemy not a harbour but a field of ruins' and it was several weeks before the port could be used. (IWM CL16)

A still taken from a film of men of No.4 Commando marching near the south coast of England to embark for their landing on Sword beach on the Normandy Coast. No.4 Commando was made up of British and French soldiers, including 177 French nationals under the command of Major Kieffer, the only French combatants who took part in the first wave of landings on 6th June. They were taken to France on board the ships *Princess Astrid* and *Maid of Orleans*, their objective on landing being the German battery at Riva Bella in Ouistreham. On landing, the Commandos came under heavy fire but managed to break out to the coastal road and set off for Ouistreham. (IWM BU1178)

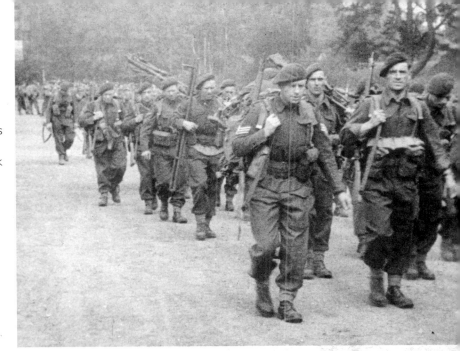

Final briefing of RAF Douglas Boston crews whose task it was to fly low near the French coast laying smoke screens to cover the arrival of Allied ships. In this photograph, which vividly conveys the tense atmosphere just before the great operation began, an American pilot and some of the crews of the famous French Lorraine squadron may be seen. (IWM CL4)

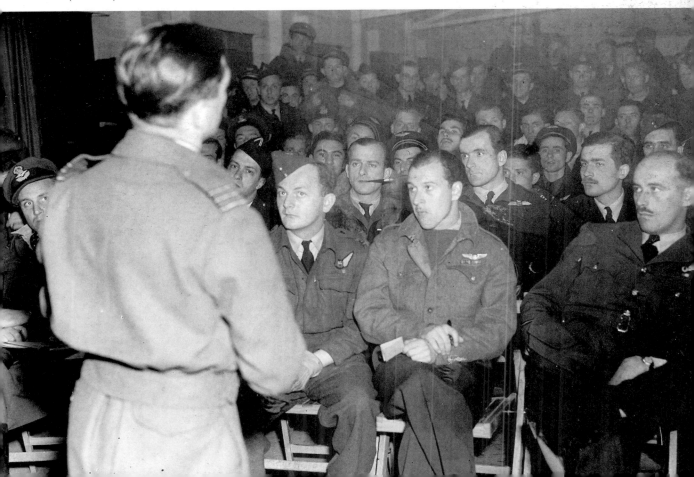

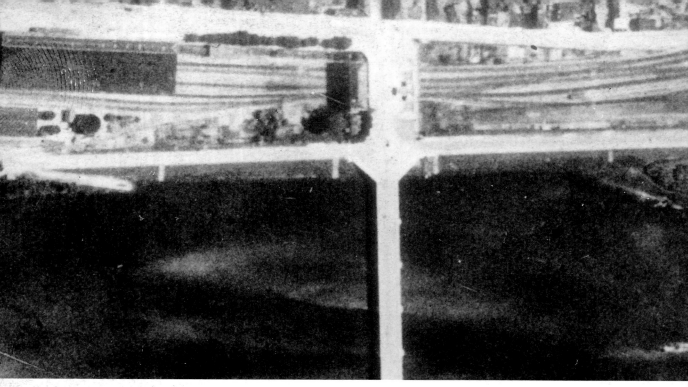

Before and after reconnaissance photographs of the railway yards at Saumur. The second shows the damage caused by the RAF bombers which attacked it on the night of 1 June. This kind of target had to be struck before D-Day to make the movement of troops and armour to the front almost impossible. Railway tracks were torn up and the yards were practically obliterated as a result of the raid. The size and number of bomb craters visible in the riverbed give a clear picture of the weight and the ferocity of the attack. However, the blast effects of bombs landing in the river mud would have been greatly reduced. (IWM CL78 & 79)

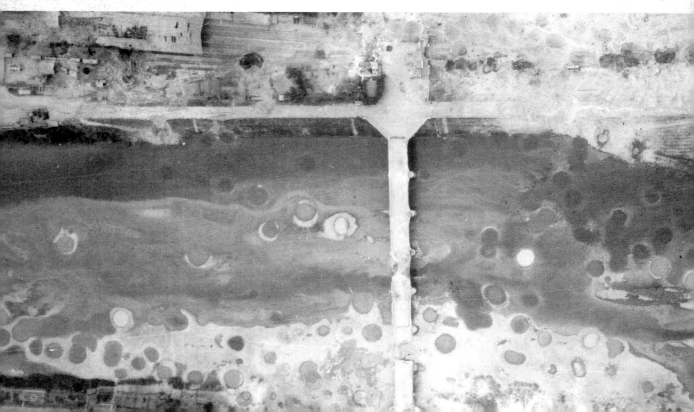

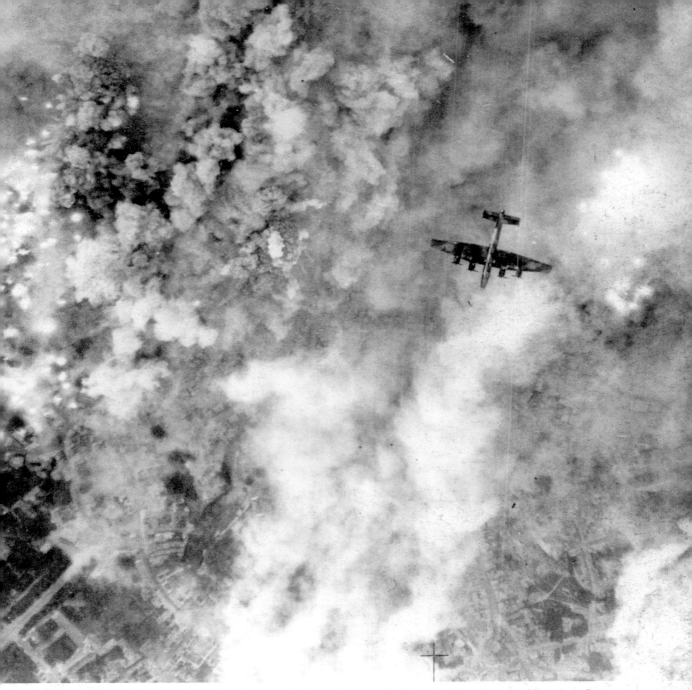

A Handley Page Halifax of Bomber Command pictured on a daylight raid. The aircraft of Bomber Command pounded enemy targets in North West France in advance of the Normandy landings. It was vital that German supplies were disrupted and that the Germans' ability to move troops to the front was undermined. Halifaxes and other Allied bombers systematically hit a list of eighty transportation targets such as railway junctions and marshalling yards. In April and May 1944 Allied air attacks dropped 195,400 tons of bombs but the cost was high – 12,000 Allied airmen were killed and almost 2,000 aircraft were lost between 28 April and 6 June alone. The Halifax had preceded the Lancaster into Bomber Command service and was the first four-engined RAF 'heavy' bomber to drop bombs on Germany in World War II. In addition to the Halifax bombers in service in 1944 some Mk.IIIs, Vs and VIIs were converted to paratroop dropping and glider towing in preparation for the D-Day offensive. (IWM CL347)

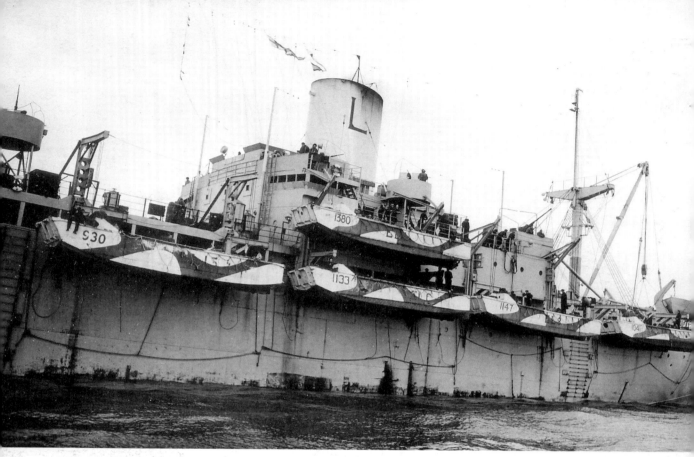

British Landing Craft are hauled up to the main-deck level of a Liberty ship. From this position it was easier for heavily laden troops to climb into the landing craft. (USA 252662)

American troops aboard their LCI (Landing Craft Infantry) check over their weapons before being put ashore. By early June 1944 more than two million troops, over 6,500 ships and 11,500 Allied aircraft were poised to to invade Hitler's Fortress Europe.

Before leaving for France, the GIs had lived for weeks in secure canvas camps all over southern England where their equipment and supplies, including huge amounts of ammunition, were also stockpiled. Days before the invasion, troops were moved to sealed holding areas where they were briefed in outline on their objectives. Each US soldier was required, in addition to carrying his weapon and wearing a uniform, to carry amongst other items: dog tags, a spare magazine of ammunition, first aid pouch, haversack, canteen cup, canteen, webbing belt, protective gloves, steel helmet (with liner), two handkerchiefs and a woollen hood. (IWM B5165)

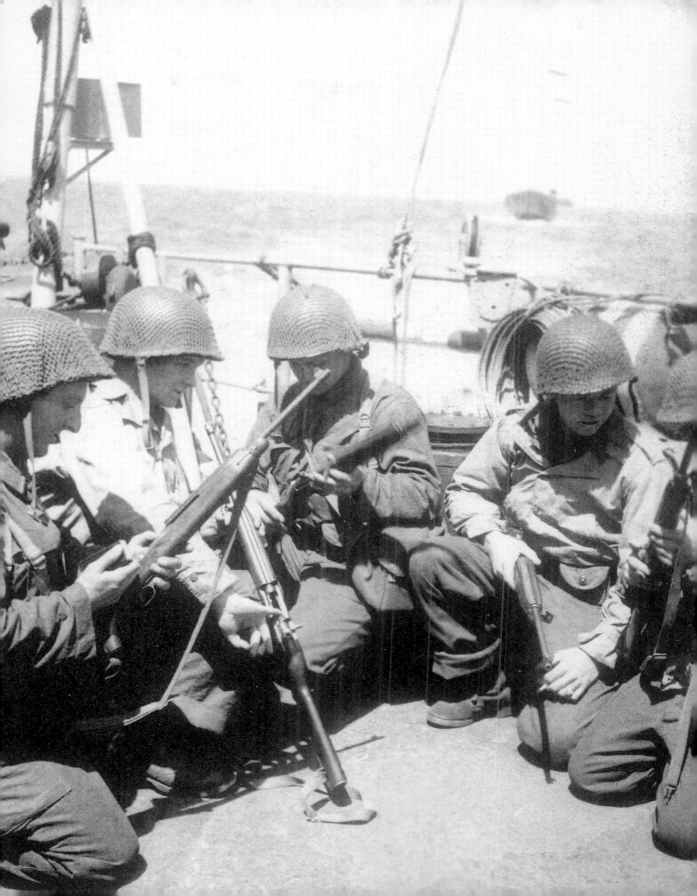

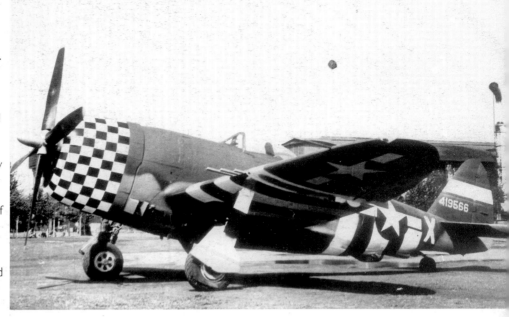

Republic P-47 Thunderbolt of the 78th Fighter Group at Duxford, Cambridgeshire. When the P-47 first flew in May 1941 it was the largest and heaviest single-seat piston engined fighter ever produced. It was also produced in greater numbers than any other American fighter and was one of the outstanding US fighters of World War II. Duxford's 78th FG provided air cover to the Allied invasion fleet as it crossed the Channel. (IWM HU31375)

An oblique RAF reconnaissance photo of the stretch of French Channel coastline between Fecamp and Etretat. Deception was a vital means of confusing the enemy throughout the war but this stretch of coast was selected as the location for a spurious Allied landing on 6 June. Operation TAXABLE simulated a large ghost convoy of Allied ships crossing the narrowest part of the English Channel. Eighteen small ships steamed towards France at seven knots, and to make their radar presence appear as that of a large convoy, overhead the the Lancasters of No. 617 Squadron (the famous Dambusters) flew in a continuous circling orbit, gradually nearing the French coast. Every four seconds for the entire three-and-a-half hours of the operation, bundles of Window (small metal strips which produced a false echo on the enemy radar screens) were thrown from the aircraft. The ruse was so convincing that German radar-directed guns opened fire on an imaginary fleet as the actual invasion was underway many miles along the coast. (IWM CL9)

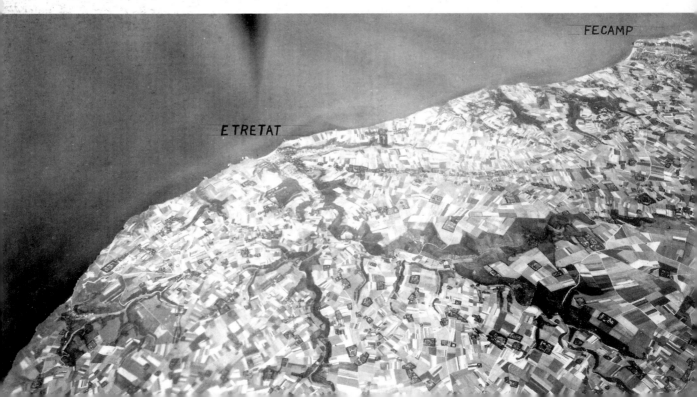

FECAMP

ETRETAT

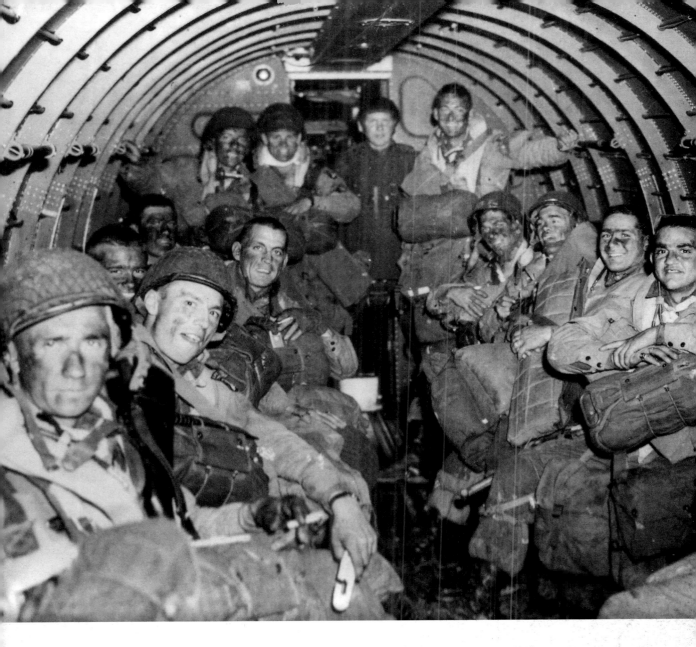

Paratroopers of the 101st (Screaming Eagles) Airborne Division wait for take-off. Poor weather scattered the American airdrops far and wide across the Cotentin Peninsula. Their smiles must conceal anxieties about what was shortly to come. (USA 15201)

Part 2
The Landings

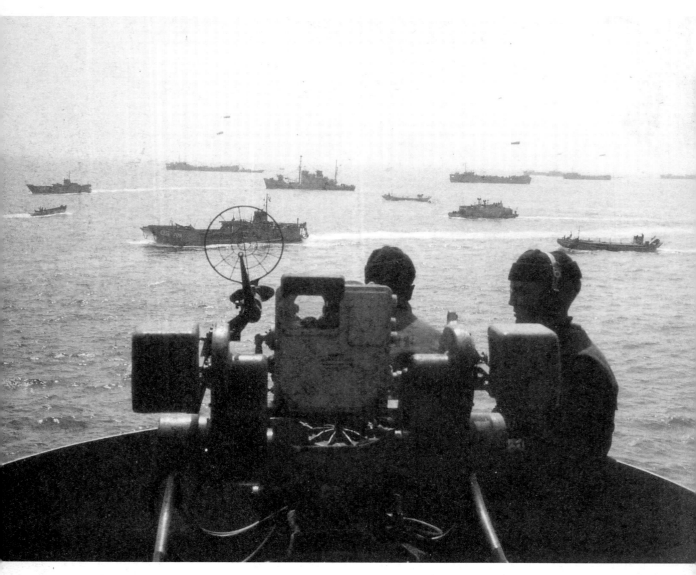

The crew of a US Destroyer anti-aircraft gun look on as landing craft sail towards Omaha Beach. During the early hours of the invasion US and British Destroyers sailed in close to the shore to give direct fire support, suppressing bunkers along the bluffs overlooking the beach and remaining ever alert for attacking Luftwaffe aircraft. (USA 252597)

Allied naval forces in Operation NEPTUNE, the naval element of the Normandy invasion, were commanded by Admiral Sir Bertram H. Ramsay. They were of course central to the success of the invasion and had to convey the ground forces to the beaches for the invasion of a hostile and defended shore. In addition, they had to cover the landings with supporting gunfire and defend the Allied lines of communication against enemy surface or underwater attack. After the landings the navies had to ensure that supplies for the invading forces continued to flow across the sea for an indefinite period. Around 4,100 ships and craft of all types were involved in the assault and within twenty-four hours the Allies had transported 175,000 troops and their equipment, including 50,000 vehicles from tanks to bicycles, across sixty to 100 miles of sea against a well-fortified enemy coast. Churchill referred to OVERLORD as 'the most difficult and complicated operation to ever take place'. (IWM EA25992)

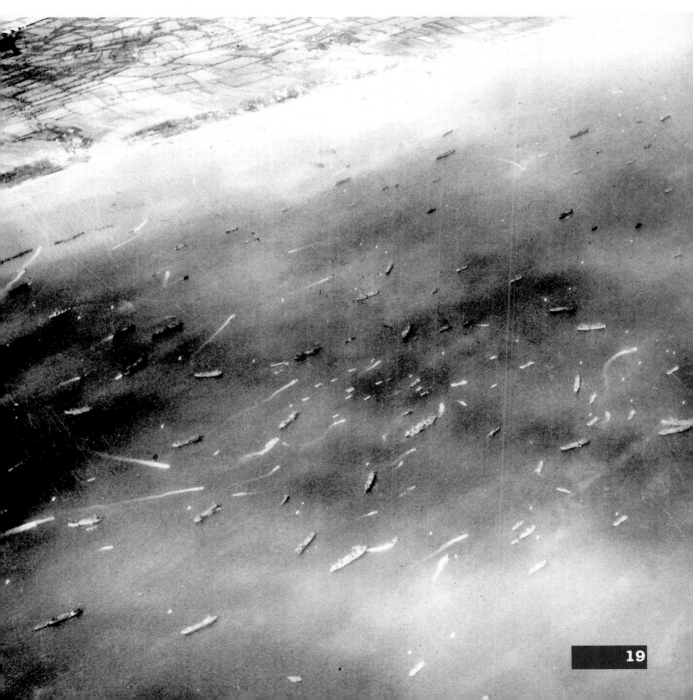

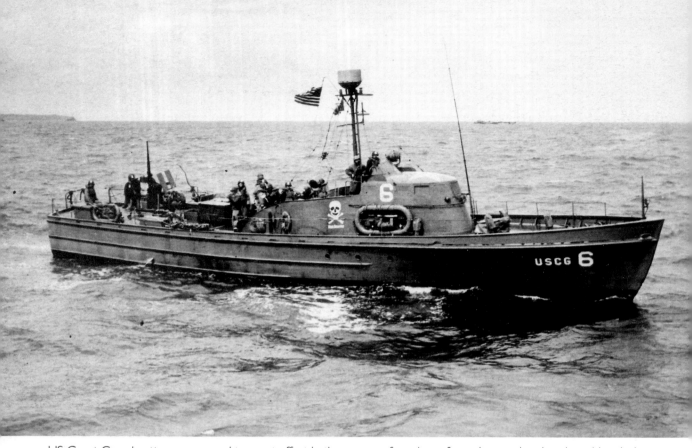

US Coast Guard cutters were used to great effect in the rescue of survivors from damaged and sunken ships during the landings. These 'maids of all work' dashed around amongst the vast armada of the invasion fleet shepherding landing craft to their destinations and running close inshore to rescue troops in danger of drowning. (USA 4078)

Although two battleships, three cruisers, twelve destroyers and 105 other ships shelled Omaha Beach as the landing craft headed for the shore, they had insufficient time to neutralise the network of bunkers and gun pits covering the beach. (USA 235592)

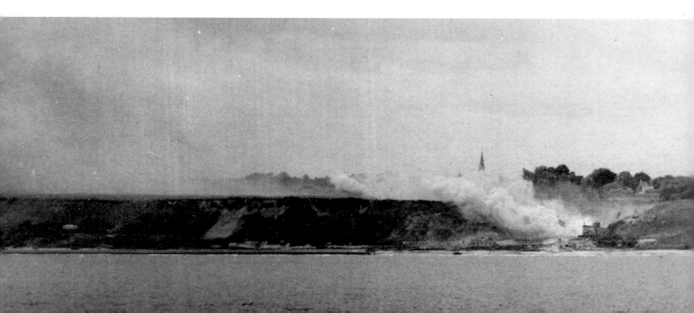

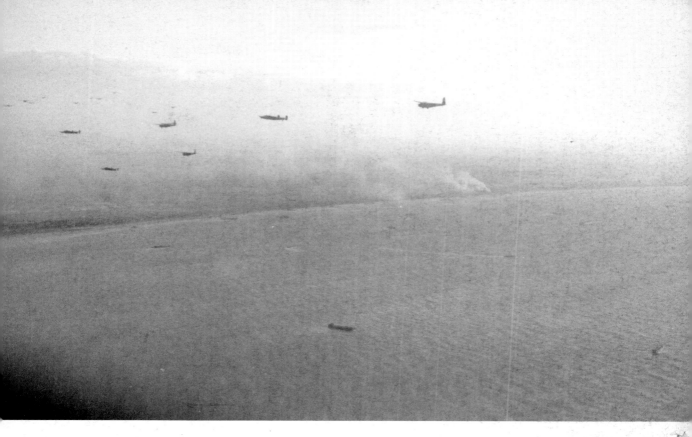

Royal Air Force Halifaxes tow Hamilcar gliders of the 6th Airborne Division towards the Normandy beaches. 335 gliders took part in the British airborne operations on D-Day and 100 glider pilots were killed or wounded. The Halifax had been a very successful bomber and a key part of the RAF night offensive against Germany. In 1944 a number of these aircraft were converted to tow the heavy Hamilcar glider. The General Hamilcar first flew in 1942 and went on to be the largest and heaviest Allied glider of World War II. The glider, with its crew of two, could carry a seven-ton tank, access for loading and unloading being via the hinged nose. Over seventy Hamilcars flew as part of the D-Day landings. (IWM CL29)

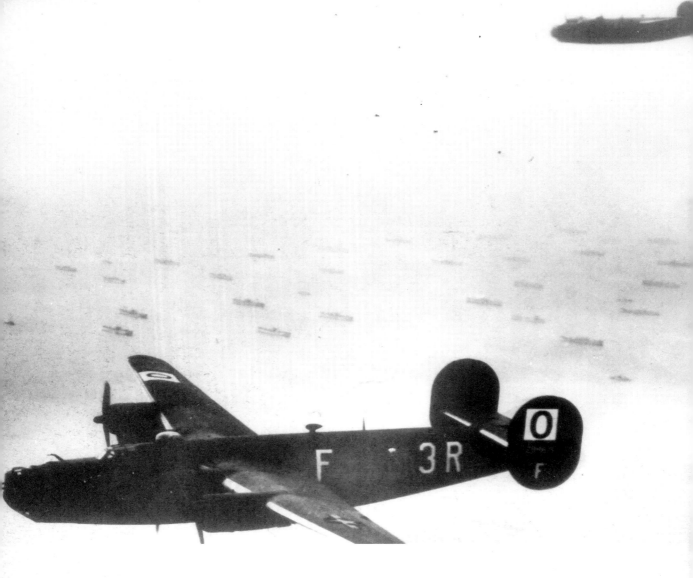

Two Consolidated B-24 Liberators of the US Eighth Army Air Force return home after bombing enemy strong-points on the Normandy coast early on the morning of 6 June. Below the B-24s can be seen part of the vast Allied sea-borne invasion armada.

The aircraft belong to the 486th Bomb Group based at Sudbury in Suffolk. The 486th was created on 14 September 1943 and was transferred to England in March of 1944. The group flew 49 missions in the Liberators until 21 July 1944 losing only eight aircraft in the period – this is a clear indication of the increasing air superiority that the Allies enjoyed as D-Day neared. The aircraft can be identified by the black 'O' in a white square painted on the tail, top right wing, and bottom left wing. The square identified 3rd Air Division aircraft, the 'O' signified the group. However, when the transition to the B-17 began it was thought the 'O' would be confused with the 'D' of the 100th Bomb Group so to remove any confusion, all 486th Fortresses were identified by a white 'W' in a black square.
(IWM EA25713)

Infantry of 4th Division wade ashore from an LST on to Utah Beach. Although the landing was over 1,000 yards south of its intended point, the German reaction was lighter than expected. The division's casualties on D-Day were minimal. (USA 07^009)

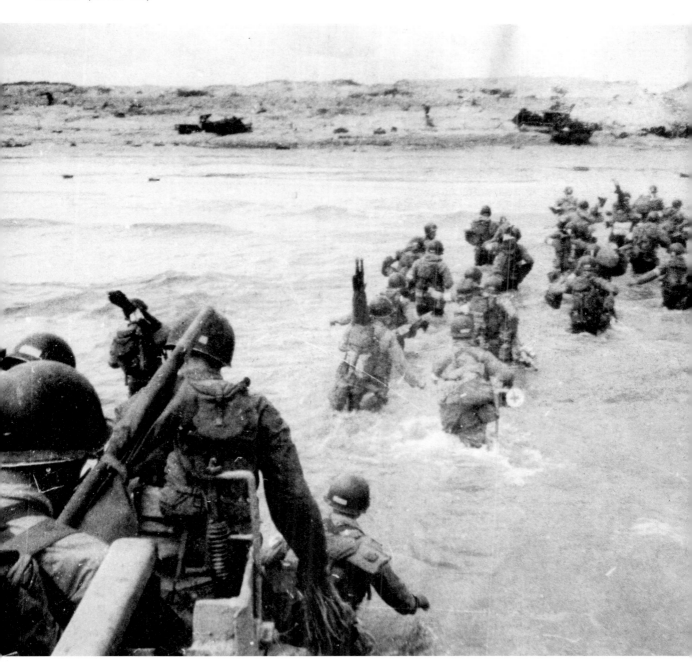

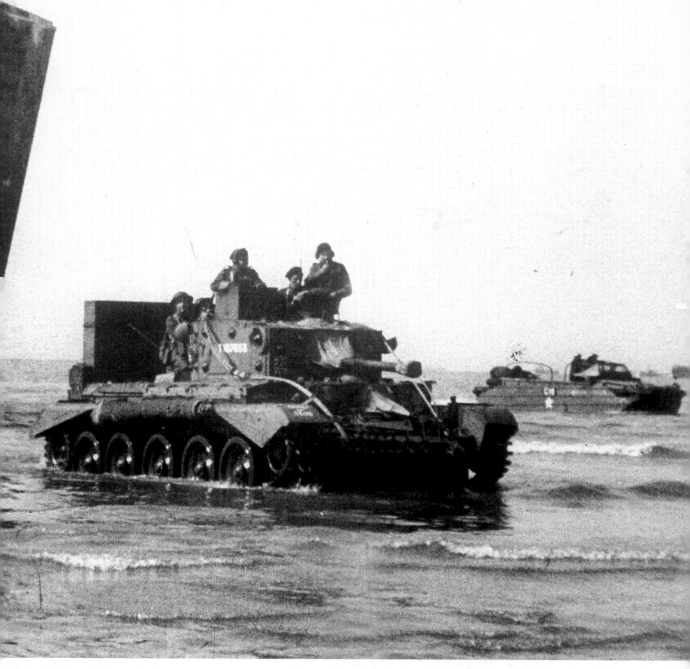

When the British Army ordered a new tank to replace the Crusader, the Leyland company was given the contract. Power for the production version came from a de-rated Rolls-Royce Merlin aero engine, named Meteor. The new tank was called the Cromwell and was not used in anger until the invasion of Normandy when it was the main tank of the British 7th Armoured Division. Although Cromwells could outrun the heavier German tanks they were consistently out-gunned by the enemy vehicles. Cromwell production ceased in 1945 but the type remained in British Army service until 1950. (IWM MH2014)

Pictured early in the morning on 6 June, Short Stirlings of RAF Transport Command tow Airspeed Horsa gliders towards France. Virtually obsolete as a bomber by mid-1943, from early 1944, the Short bomber became a very effective glider-tug and transport aircraft. RAF Stirling units in action on D-Day were Fairford Common-based Nos 190 and 622, and from Keevil Nos. 196 and 299 Squadrons. As well as its glider-tug duties, the Stirling was used to drop food supplies and ammunition to the French Resistance and also to drop airborne troops. The Stirlings were also used in support of the 2nd Tactical Air Force transporting 120 five-gallon jerry cans full of petrol at a time. (IWM CL21)

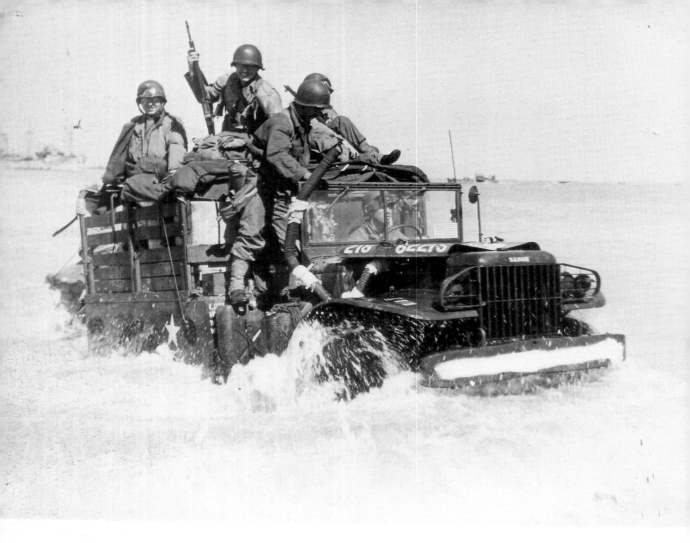

An American 4 x 4 Dodge light truck comes ashore. Note the flexible hose air-intake taped to the nearside windscreen. This was an obvious necessity in conditions like this. Bulldozers waited on the shoreline, ready to pull stranded vehicles to safety. (USA28895-FN)

Douglas C-47 Skytrains of the Ninth Air Force. These aircraft were the backbone of the US 9th Troop Carrier Command and enabled the Allies to carry out mass air-drops as dawn broke on D-Day.

The Allied assault on Hitler's Fortress Europe began with the greatest airborne operation in history. In the first thirty-six hours of the Allied invasion, over 1,600 paradrop and glider-towing missions were flown to the area of St Mère Eglise alone. Under the command of Brigadier-General Paul L. Williams, US 9th Troop Carrier Command's (9th TCC) fourteen groups of C-47s carried the 82nd and 101st Airborne Division to their designated drop zones (DZs) in the Carentan-St Mère Eglise sector. By the time the last drop was made at 0404 hours, the 9th TCC had carried out 821 C-47 sorties. In all some 20,000 airborne forces were flown to France in 1,400 transport aircraft, and 3,500 gliders.

The C-47 was a military version of the hugely successful DC-3 airliner which had first flown in December 1935. (IWM EA74538)

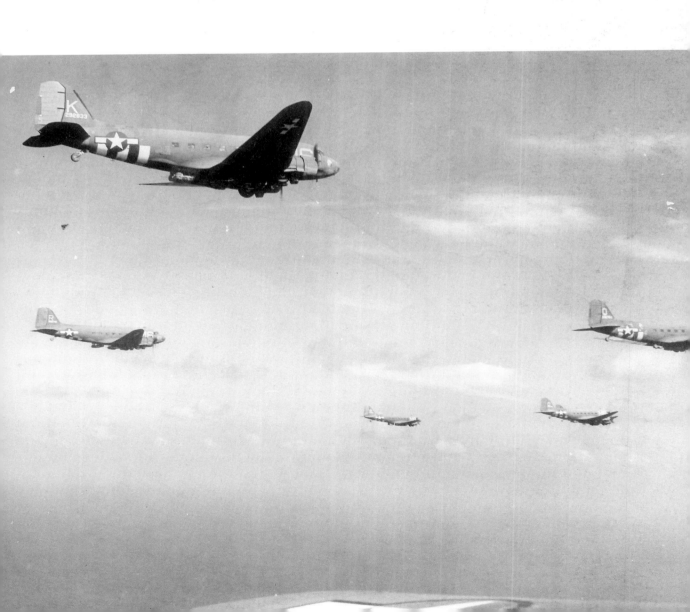

A Royal Air Force Typhoon pilot, identified at the time as Sergeant Pilot H. Hardman, watches Typhoons returning from a sortie. Armed with rocket projectiles, the Typhoon carried out vital attacks prior to the D-Day landings on German radar stations in the Channel. Typhoons attacked radar installations on 2 June at Dieppe, Caudecote and on 5 June at Cap de la Hague. These high risk daylight attacks against heavily defended targets robbed the Germans of their radar 'eyes' when they needed them most. (IWM CH9259)

Troops pour ashore onto Omaha Beach as naval guns pound the German positions on the heights in the near distance. Once engineers had blasted channels through the lines of obstacles lining the shore, landing craft were able to come in close at high tide. Many of the troops involved suffered from sea-sickness during the long voyage across the English Channel and these last few steps ashore wading through icy cold water and under intense gunfire would have been hell on earth. (USA 487287c)

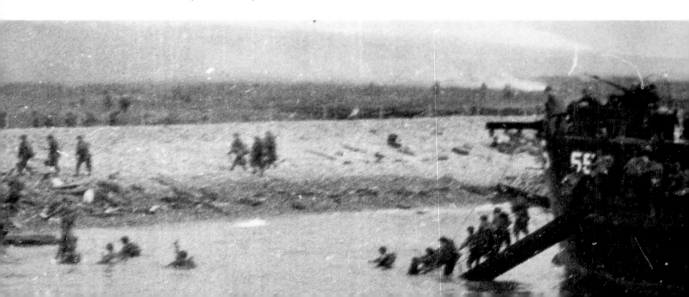

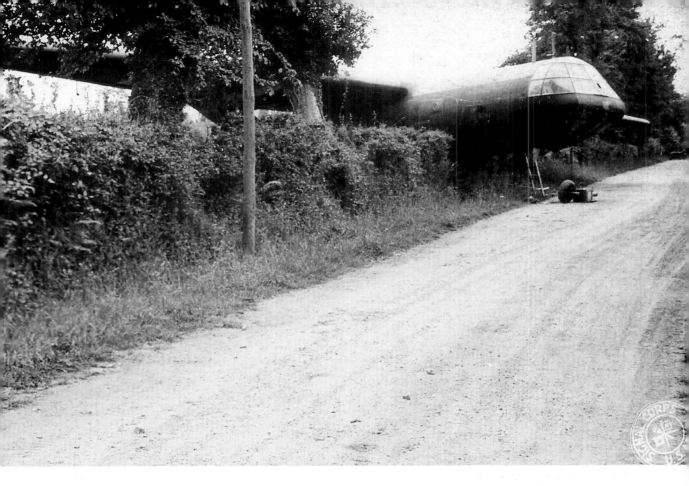

The Normandy bocage was a death trap for many glider borne troops of the 82nd and 101st American Airborne Divisions. The pilot of this British-made Airspeed Horsa glider managed to land his craft in a field close to Hiesville but could obviously have done with a little more open ground. The Horsa carried a two-man crew and could carry twenty-five fully equipped soldiers or equivalent weight of cargo. Note the broken nose-wheel lying in the road and the escape ladder that suggests everyone evacuated the aircraft safely. (USA 10231)

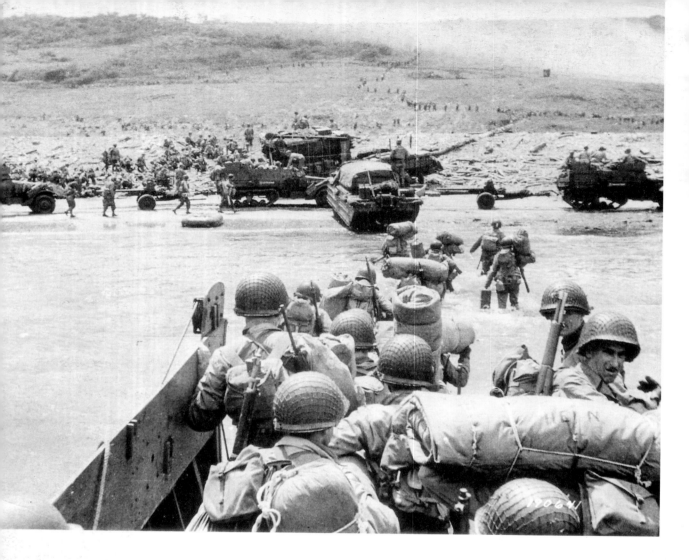

Landing on Omaha Beach on 6 June. Assault troops wade ashore from an LCVP (Landing Craft Vehicle Personnel). Halftracks and a DUKW make their way along the beach. Smoke from fires started by the naval bombardment drift along the bluffs overlooking the beach. (USA 10361)

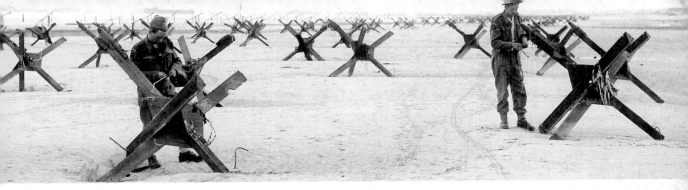

Royal Marine Commandos preparing to use explosives to demolish two of the many beach obstacles designed to hinder the advance of an invading army. Once these demolition experts were landed, they systematically set about destroying defensive obstacles including these tetrahedra by placing a number of explosive charges about them which simply blew them apart. The removal of these obstacles was vital for the safe landing of subsequent landing craft, many of which were lost to these obstacles when hidden by the tide.

In the US forces, men of the Civil Engineer Corps were among the very first to go ashore at Omaha beach. These officers commanded Naval Combat Demolition Units, which had the extremely hazardous mission of landing before the assault troops and blowing gaps in enemy beach obstacles. British and American demolition units did their work under heavy enemy artillery, mortar, and small arms fire and consequently suffered very heavy casualties. (IWM A23992)

A British gun crew manning a Bofors gun stands ready to open fire on enemy aircraft should they appear whilst the Landing Ships' Tanks are unloaded on a D-Day beach. Note the number of hydrogen-filled barrage balloons protecting the Allies ships and troops. The Luftwaffe was seen as a real threat and constant watch was kept for dive-bombing and strafing attacks.

The 40mm Bofors L/60 Light Anti-Aircraft Gun, based on a Swedish design, was widely used by British forces during World War II. It could fire a high explosive two-pound (907g) shell up to altitudes around 5,000ft (1,525m). The gun was also used on board ship as protection against enemy air attack. (IWM B5152)

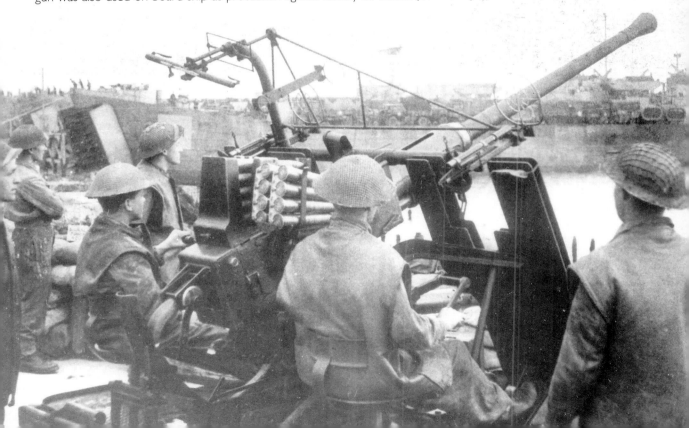

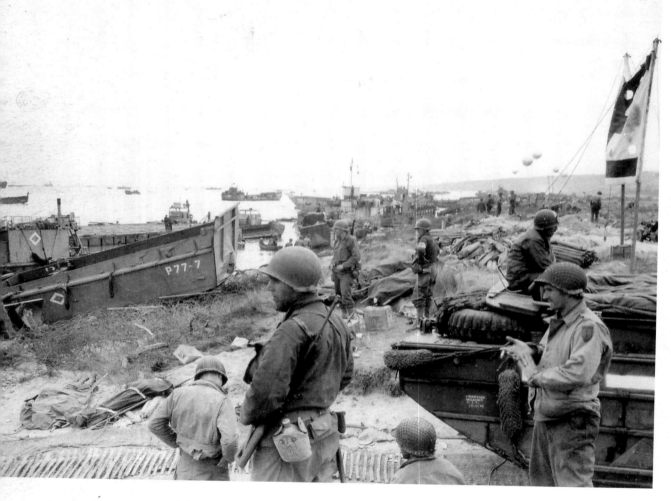

Landing craft deposit their load on Omaha Beach at high tide. The flag on the right indicates a beach exit, one of many opened by engineers with their bulldozers. They guided landing craft, manned by members of the US Coastguard, to the correct assembly points from which the equipment and troops could move inland. (USA 557)

Royal Air Force barrage balloons probably pictured at King sector of Gold beach near Mont Fleury. In support of the Allied landings in Normandy, the RAF provided constant balloon and fighter cover over the beaches and inland as the troops moved forward. Over 4,000 RAF balloon personnel crossed the sea with the invading troops to provide this invaluable and cost effective element of Allied air defence protecting beaches then artificial harbours, captured ports and ammunition dumps. The hydrogen-filled balloons could be raised or lowered to the required height by a winch and forced enemy aircraft to higher altitudes thus reducing their bombing and shooting accuracy. (IWM CL42)

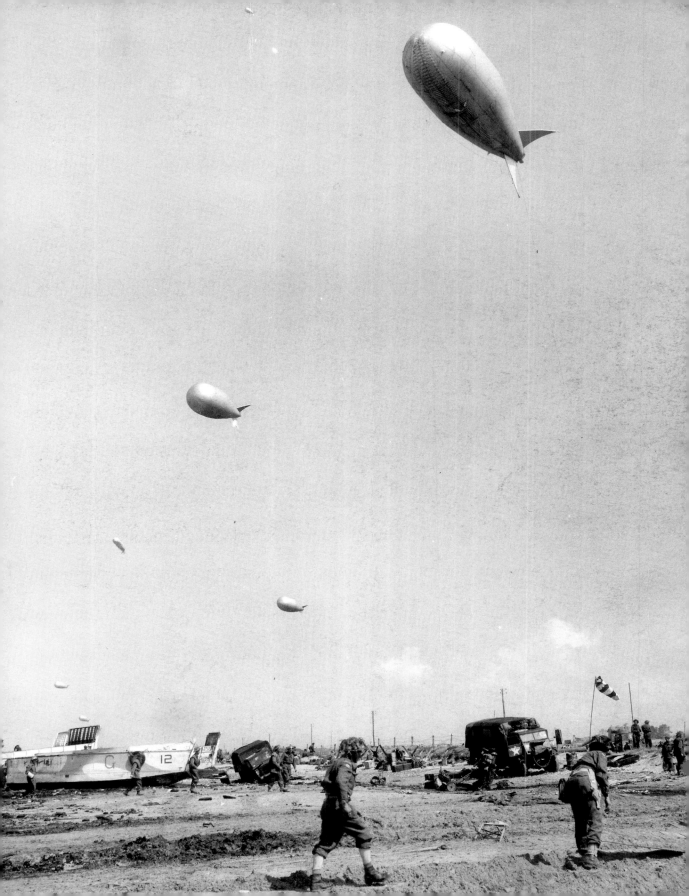

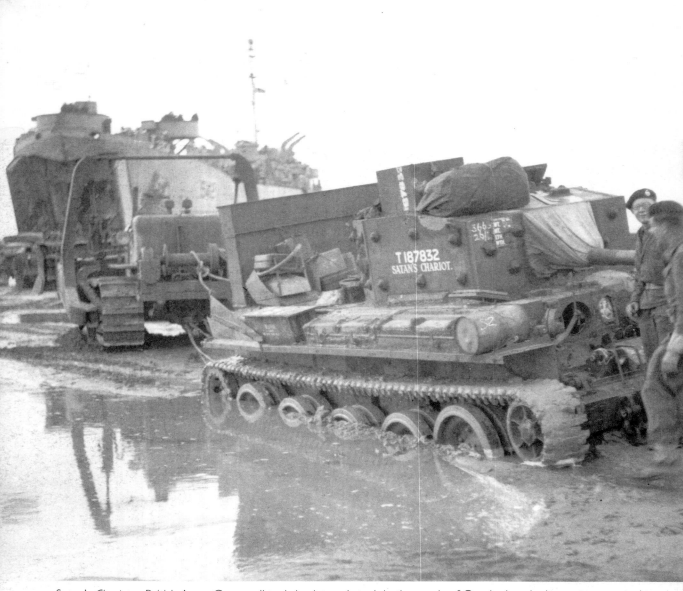

Satan's Chariot, a British Army Cromwell tank, is pictured stuck in the sands of Omaha beach. It was transported to the Normandy coast by the Mark 6 Landing Craft (Tank) LCT-542 seen in the background. LCTs were built in two versions, the 286 ton displacement Mark 5 and the larger Mk 6 which measured 119 feet long with a beam (width) of 32 feet. Manned by a crew of twelve, the Mk 6 had a bow and a stern ramp for faster loading and unloading. These craft carried their own defence in the form of two 20mm anti-aircraft guns and four .50 calibre machine guns. LCT-542 was laid down on 7 September 1943, launched on 22 September 1943 and was delivered to the US Navy in October, such was the speed of manufacture in a time of great military need. (IWM B5580)

Landing craft of every shape and size bring supplies to Omaha Beach. The larger craft sport barrage balloons to guard against aerial attack. In the foreground the Germans were building another gun emplacement to cover the beach; it was never finished. (USA 2521)

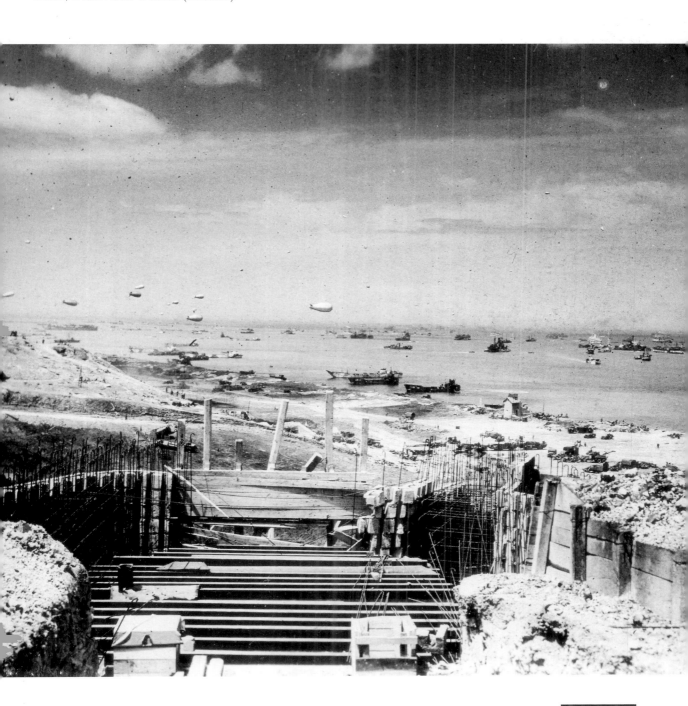

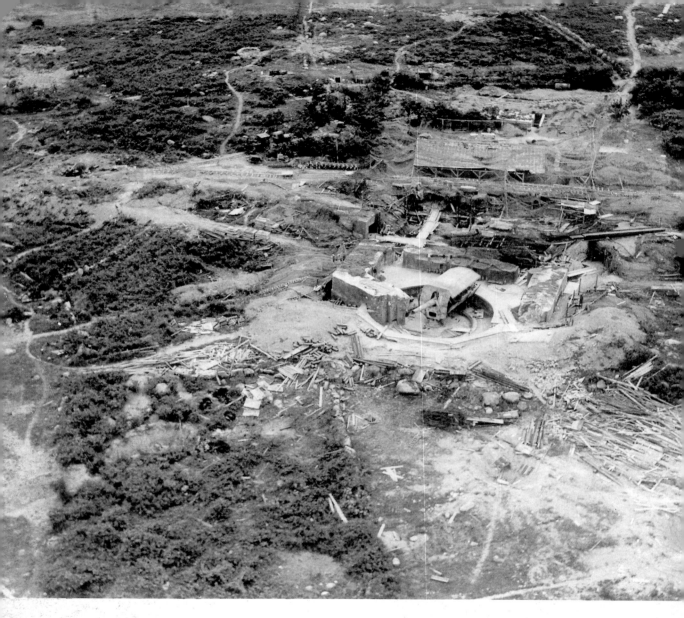

An oblique aerial photograph shows coastal defences around Cherbourg and the damage caused by the Allied naval and artillery bombardment which preceded the capture of the city and its port on 27 June 1944.

In order to provide Allied invasion forces with the necessary supplies, the Allies needed to establish port facilities in France as quickly as possible. Cherbourg, a deep port located on the northern tip of the Cotentin peninsula, was both perfect and essential and the capture of this city was a high priority for the Allies. Original plans had called for the port to be taken between 14 June and 21 June by the US 4th and 90th Infantry Divisions.

The temporary Mulberry harbours constructed offshore at Omaha Beach and Arromanches were an innovative alternative until Cherbourg could be captured. American forces of the VII Corps entered Cherbourg on 24 June, and three days later the city's German occupiers formally surrendered. Although Cherbourg was now under Allied control, the Germans had damaged the city extensively, and it took weeks to make the port operational.

(IWM EA29420)

Eight men were killed as this Horsa glider came to grief near Hiesville. The Germans had flooded large areas and built a network of anti-glider defences across the Cotentin Peninsula to guard against an airborne landing. Once freed from the tow aircraft, a glider pilot had but a single chance to land safely. In many instances they were unsuccessful because of rough terrain, obstructions or other gliders in close proximity. (USA 10334)

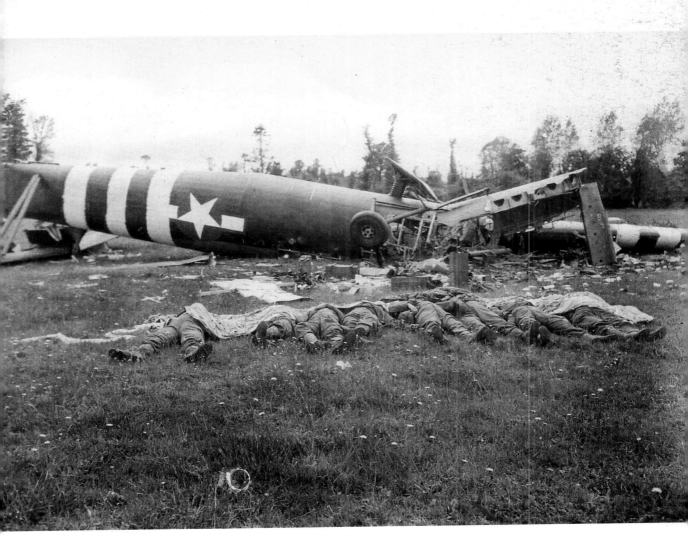

Utah Beach. Jeeps bearing stretchers wait on the shore as medics manhandle the wounded onto a landing craft. The time it would take the injured men to reach hospital facilities varied according to their plight. There were hospital ships offshore and a continuous stream of naval craft ferried the wounded back to mainland England to the many specially prepared hospitals near the south coast. (USA 252625)

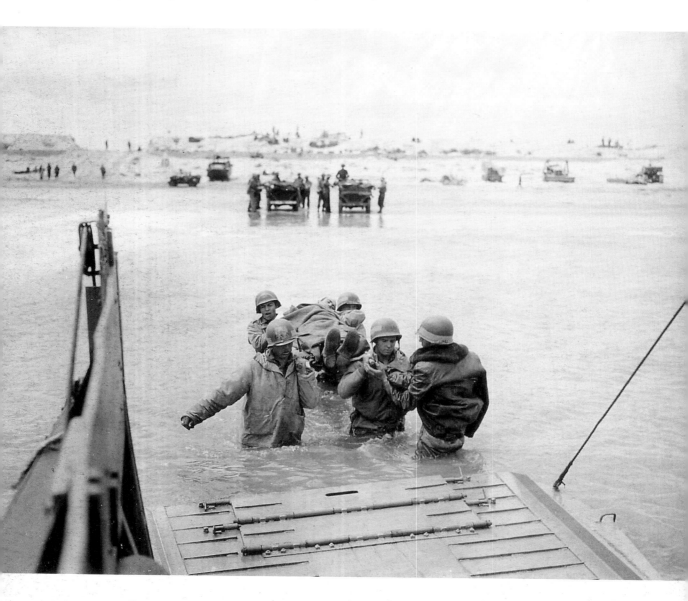

US army medics transferring stretchers from an LCVP onto one of the larger landing craft. The rough weather conditions experienced soon after the landings made this vital work extremely hazardous and often impossible. (USA 252743)

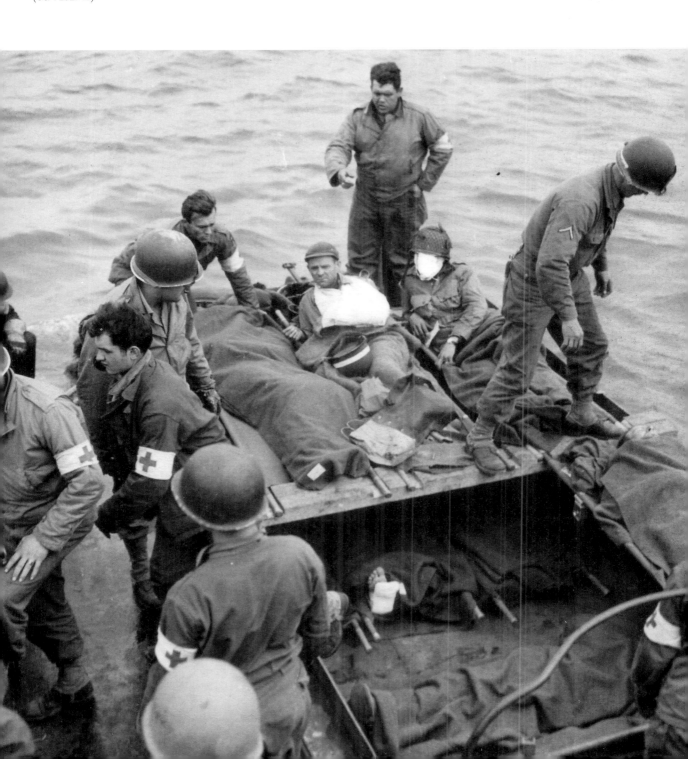

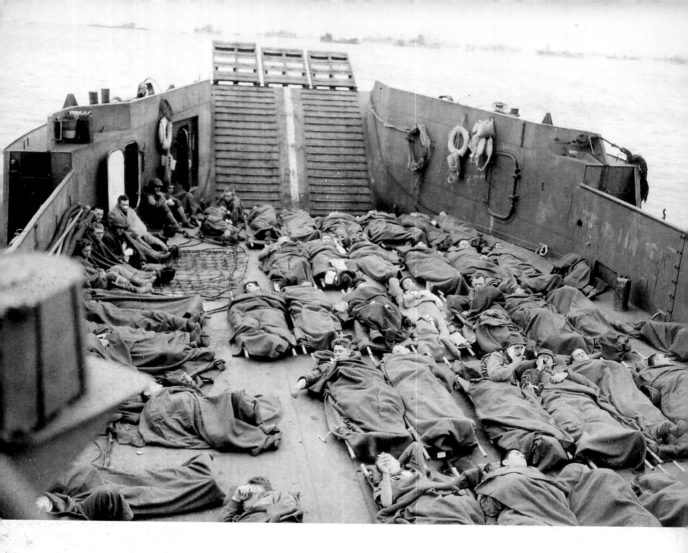

A landing craft loaded with wounded troops ploughs its way through the rough seas off the Normandy coast to a waiting hospital ship. (USA 252846)

Part 3
Establishing the Beach-head

This 219mm German gun targeted American troops as they landed on Utah Beach. It continued to shell the 4th Division as it pushed north towards Cherbourg. The bunker complex was eventually silenced on 21 June by air and naval bombardments. (USA 10343)

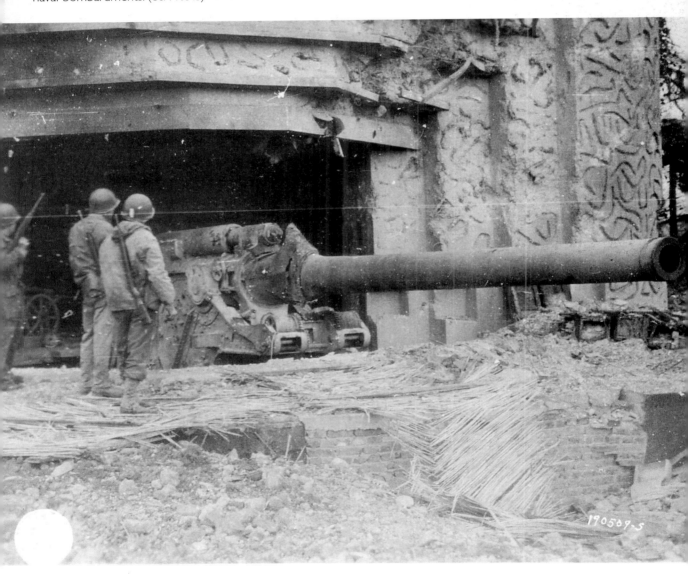

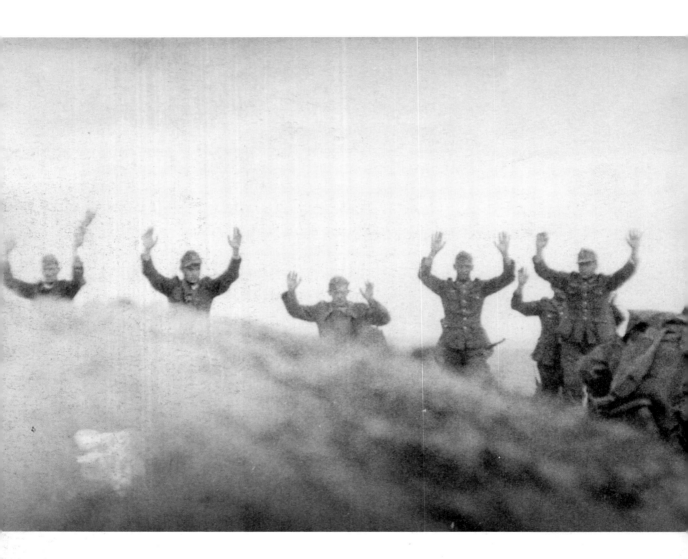

German soldiers, former 'Herrenvolk', come over the crest of a hill with their hands held high while an American GI keeps them covered. The variety of troops in the Normandy area led to a belief among Allied troops that only the hardened Nazis preferred to fight, while garrison troops and those from German occupied countries often surrendered easily. (USA 10163)

A burial party begins the grim task of creating a mass grave for those who did not survive the early hours of battle. The US VII Corps' casualties during the battle for Cherbourg and the Cotentin Peninsula exceeded 22,000. (2,811 killed in action, 13,564 wounded and 5,665 missing in action.) (USA 231417)

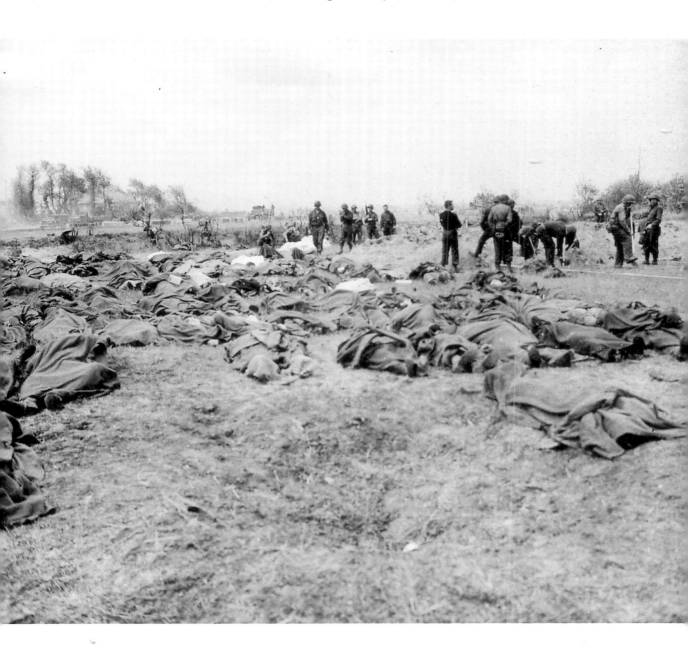

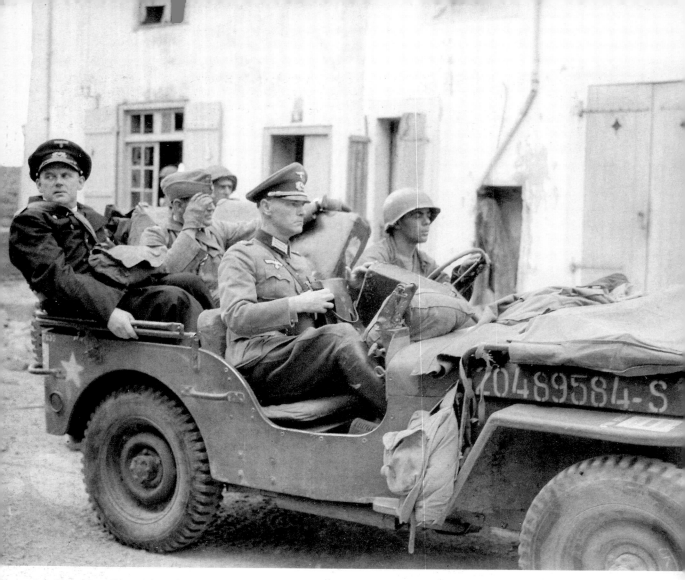

German officer prisoners of war pictured in an American jeep. These were valuable assets to the Allies provided they could be debriefed effectively. Information about German defence plans, troop concentration locations and strength were all intelligence that the Allies needed to get as soon as possible. One of the backseat passengers of the jeep seems to be reluctant to be photographed. (IWM CL833)

Sergeant H. Charlesworth of Sandbach, Cheshire and Leading Aircraftman D. Rutter of Chichester, inspecting a German anti-aircraft gun built in a pit near the King sector of the Gold invasion beach. By the end of D-Day, the Allies had flown a total of 14,674 sorties and lost 113 aircraft, mainly to flak delivered by weapons like this 20mm Flak 30 designed by Rheinmetall. This weapon could fire a 120g high explosive or incendiary shell to altitudes of 6,560ft (2,000m). (IWM CL47)

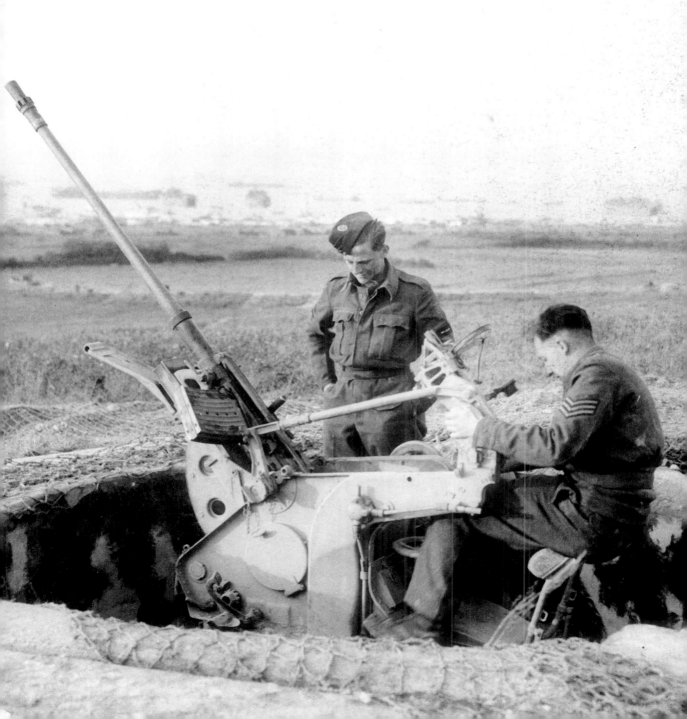

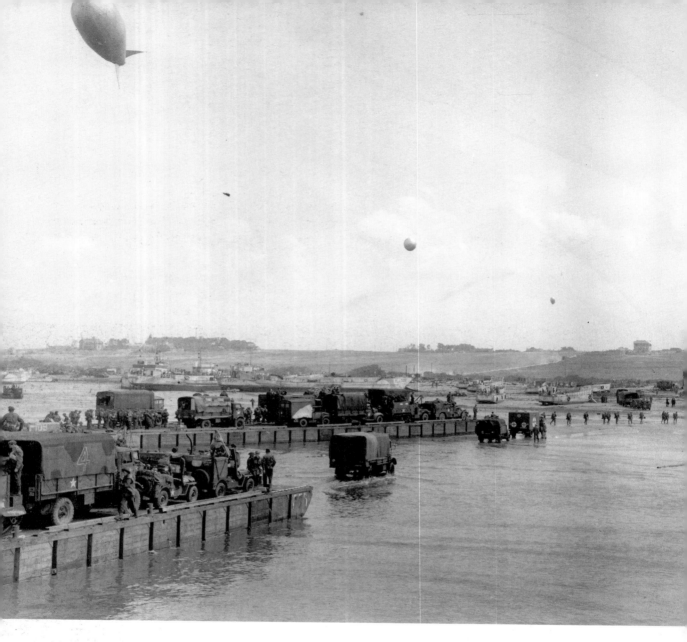

Men and motor vehicles, many of them of the Royal Air Force, make their way to or up the beach which had been assaulted twenty-four hours earlier. (IWM CL57)

Members of a US Naval shore fire-control party set up their radio in a shell hole on Les Dunes des Varreville. For the first few days of the invasion ground troops relied heavily on naval gunfire support and small front-line units such as this would guide the ship-board gunners onto their targets by relaying the exact enemy position and then the Allied fall of shot. (USA 10518)

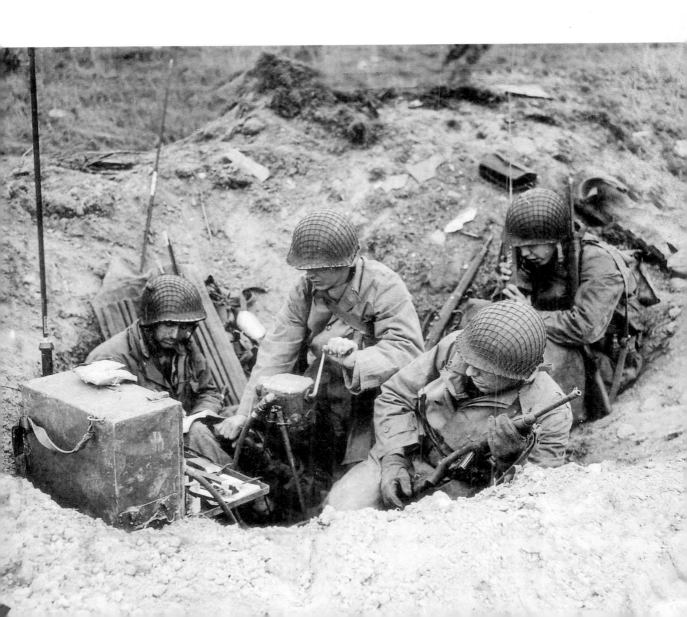

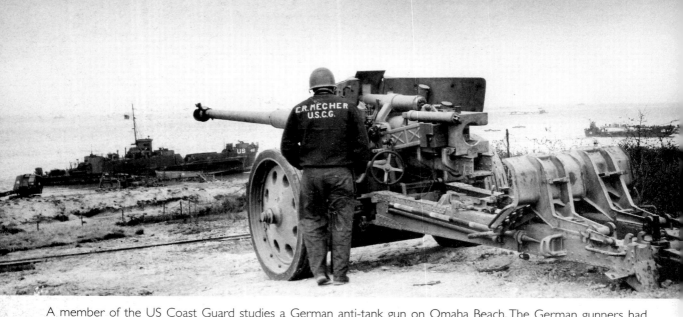

A member of the US Coast Guard studies a German anti-tank gun on Omaha Beach. The German gunners had plenty of time to target the approaching landing craft as they moved slowly towards the shore. (USA 2398)

Men of the Royal Engineers making the landing strips on which the RAF Transport Command aircraft landed. This interlocking medium gauge metal mesh was essential for the operation of the heavier transport aircraft such as Dakotas. (IWM CL123)

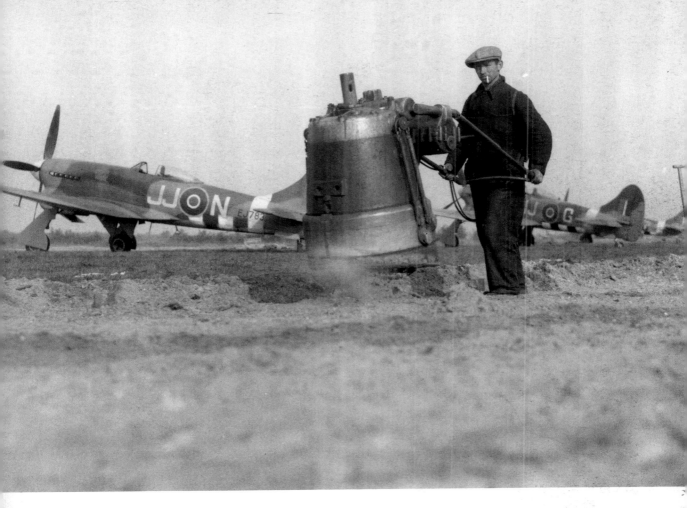

A 500 kilogram stamper left behind by the Germans is here being used by a Dutchman in preparing a dispersal point on an Allied airfield. The aircraft in the photo are Hawker Tempest Vs which were then operating from these advanced airfields in Holland. The 'JJ' codes on the aircraft identify them as being from No.274 Squadron which swapped Spitfire IXs for the Hawker fighters in August 1944. The Tempest was developed from the Typhoon and differed from its predecessor mainly by its lengthened fuselage and a new thin-section laminar flow wing intended to improve the Typhoon's disappointing climb and altitude performance. Five versions were planned to test various engine installations but only three ever saw service – the Mks II, V and VI. The first Tempest to fly, the Mk.V, was a modified Typhoon which took to the air in September 1942.

The Mark V was powered by a Napier Sabre II while the Mark VI had the 2,340hp Sabre V. Only the Tempest Mark. V, retaining the Typhoon's distinctive chin radiator, saw wartime service, the first RAF Tempest wing being formed in April 1944. After initial train-busting and ground-attack duties, the Tempest V was used to tackle the incoming V-1 flying bombs and excelled in the role. The Tempest V was the fastest fighter tasked with UK air defence and destroyed 638 V-1s between 13 June and 5 September 1944. As part of the 2nd Tactical Air Force, Tempest Vs destroyed 20 Messerschmitt Me262s jets in air combat. (IWM CL1454)

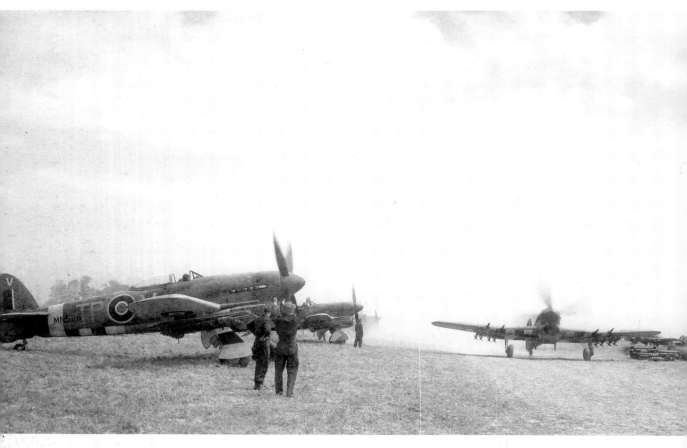

Hawker Typhoon IBs of No. 198 Squadron, 123 Wing, 84 Group, 2nd Tactical Air Force, taxiing through clouds of dust around the airfield perimeter. The airfield is probably not their first in France since they had to leave Plumetot because it was waterlogged. They later returned to Martragny and were highly successful operating in the close-support role, attacking tanks and other German vehicles. The toll was high and during one short period the Squadron lost nine aircraft. 123 Wing was especially effective in destroying tanks during the Falaise counter-offensive by the German Army. (IWM CL471)

'Wooden Wonders' in action as bombs from low-flying de Havilland Mosquitoes straddle an enemy vessel off Royan at the mouth of the Gironde River. De Havilland Mosquitoes of Royal Air Force Coastal Command carried out relentless attacks against enemy shipping to ensure that the German forces in Western Europe were under pressure from every quarter. On 12 August 1944 Mosquitoes flew up the mouth of the Gironde and attacked enemy minesweepers and trawlers with bombs and cannon fire, scoring a direct hit with bombs on a minesweeper which blew up. Two armed trawlers were also raked with cannon fire and damaged in the attack.

The Mosquito became the most versatile aircraft to see action during World War II and was a true multi-role warplane. The Mosquito design began in late 1938 as a private venture bomber/reconnaissance aircraft that could fly so fast and high it would need no defensive armament. Wooden construction was chosen because it was very strong when laminated and also kept the weight down, thus providing an excellent high-performance airframe. Another advantage of using wood was that furniture building sub-contractors could make the fuselage, wings and tail-plane without disrupting Britain's already overstretched aircraft industry. The use of wood also avoided the use of scarce metal products.

The first Mosquito prototype was in Bomber configuration and with its clean airframe and powerful Merlin engines, the aircraft soon proved that it had exceptional performance and handling characteristics. The Mosquito remained the fastest combat aircraft in the world until 1944. (IWM C4551)

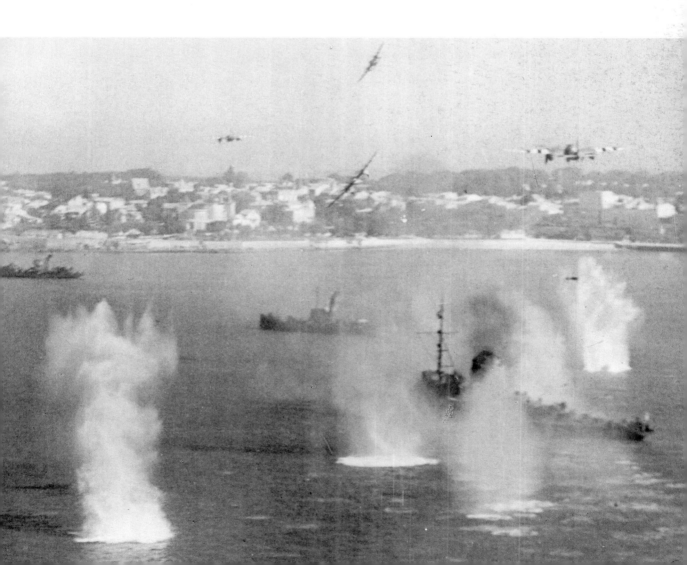

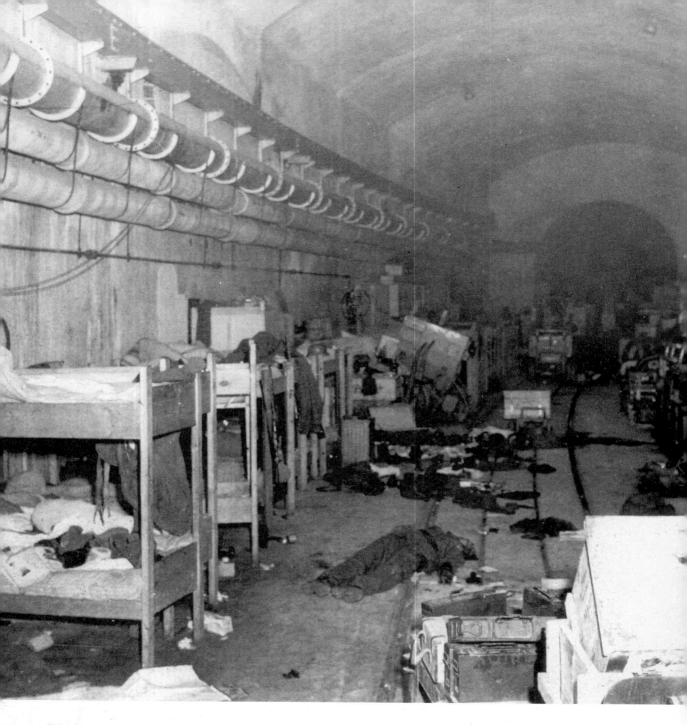

This photograph dated 27 June 1944 was taken in the sleeping quarters of personnel based at the underground defences in Cherbourg which the caption of the period states '...formed part of Hitler's allegedly 'impregnable' Atlantic Wall'. The Germans apparently fought on even in the face of overwhelming enemy forces. (IWM EA27954)

A view of one of two floating roadways at the Arromanches artificial harbour. The artificial Mulberry Harbours were essentially a massive jigsaw, designed in secret and then built in sections throughout Britain by workers who would never have believed the end use of the strange concrete structure they were building. The component parts were towed across the English Channel by an armada of 150 tugs and presented the Allies with a working harbour without a high risk and costly assault on a harbour which may have been booby-trapped. The invading Allies brought everything with them so why not a harbour too? Artillery pieces, heavily laden trucks and even tanks would be unloaded and driven along the Mulberry to a dry beach. (IWM B7240)

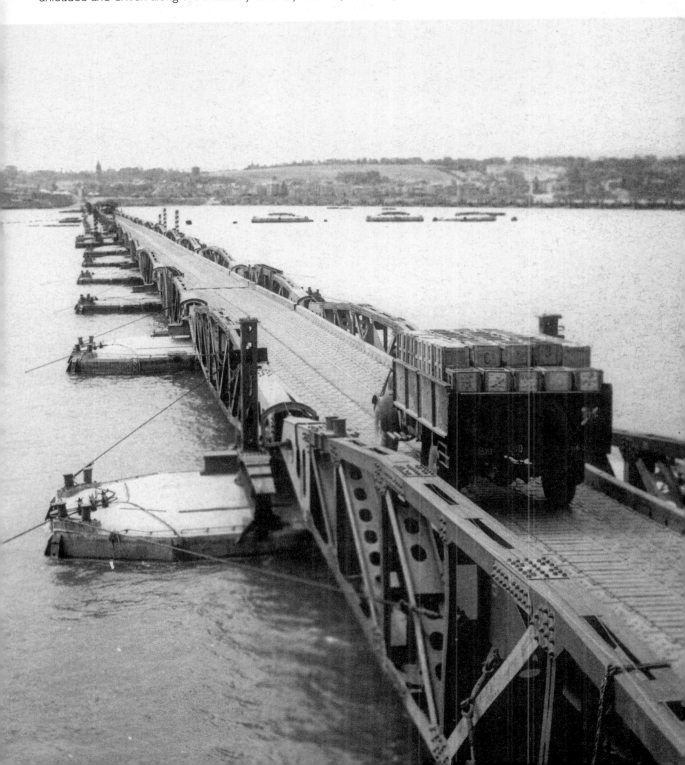

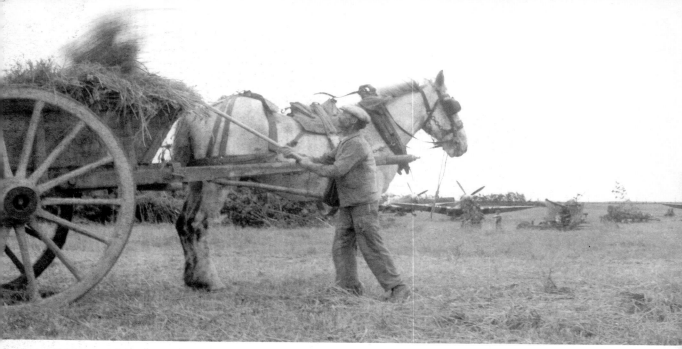

Life goes on for a French farmer as he pitchforks straw onto a cart during the summer of 1944. Parked nearby on a makeshift dispersal are Spitfires of an unknown Royal Air Force unit using the farmland as its base. The Spitfire IX was the most numerous mark of the famous Supermarine fighter in use with the 2nd Tactical Air Force at the time of the Normandy invasion although the Griffon-engined Mk XIV had entered service in January 1944. The Spitfire was unique in that it was the only Allied fighter to remain in continuous production throughout World War II. Notice the ground equipment including trolley starters camouflaged by branches and foliage. An anti-aircraft gun sits just forward of the aircraft to deal with unwelcome attention from the air. (IWM CL90)

Hawker Typhoon F Mk IB of No. 198 Squadron with its 2,180hp Napier Sabre IIa engine taxiing through the trademark dust clouds that typified Normandy's primitive airstrips. (IWM CL472)

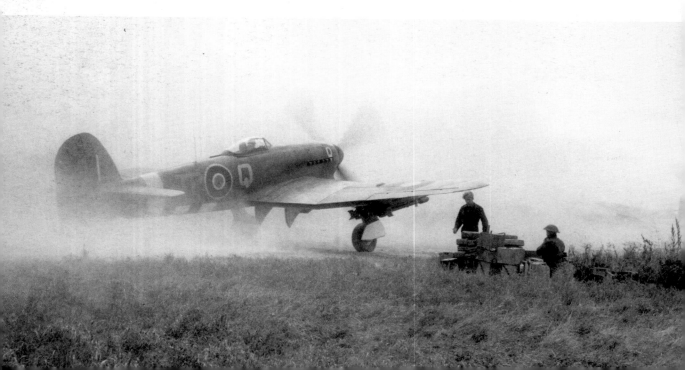

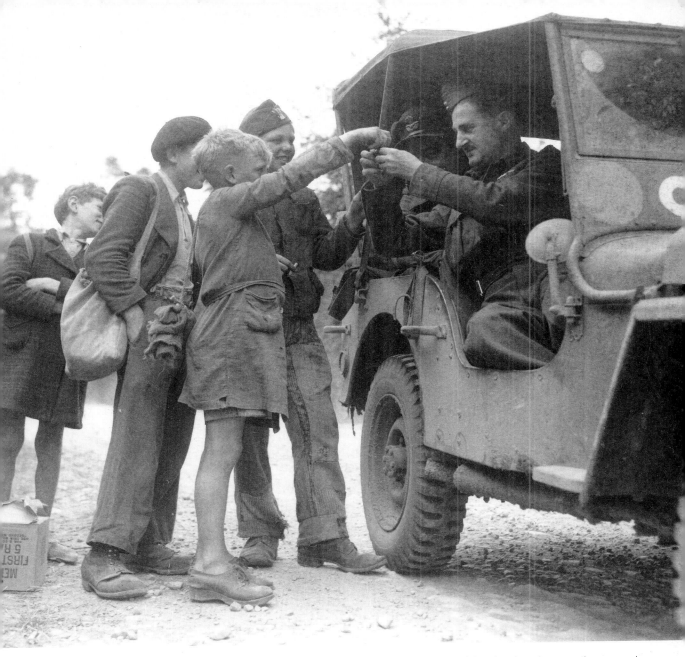

Royal Air Force personnel and French children in July 1944. Despite the discarded food rations box on the ground it would appear that the children are being given cigarettes and not sweets. The boys may have been refugees and judging by their appearance may have been living rough for a time.

The vehicle is an RAF example of the famous 'jeep', over half a million of which were produced during World War II. When World War II broke out, the United States issued an urgent requirement for a new small four-wheel drive utility vehicle. A design proposed by Willys was accepted and large-scale production began with Ford producing large quantities of the vehicle. (IWM CL301)

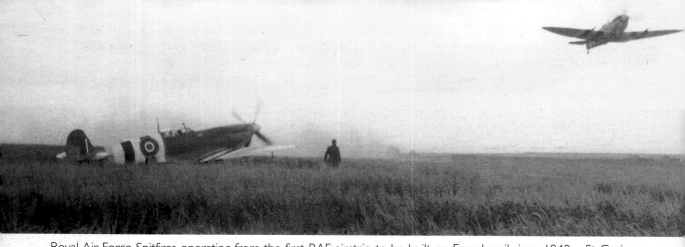

Royal Air Force Spitfires operating from the first RAF airstrip to be built on French soil since 1940 – St Croix-sur-Mer. Note the thick cloud of dust that marks the airborne aircraft's take-off run. Dust was to cause major headaches for the Allied air forces on these newly created forward air strips. It was not only the loss of visibility until the dust cloud had settled, but it also found its way into engines and armament where it caused havoc with the machinery. (IWM CL88)

A British Army stretcher case being loaded into an RAF Douglas Dakota transport for the journey back to England. As soon as usable and suitable airstrips were available aircraft of Royal Air Force Transport Command would fly supplies, including frozen blood in special containers, to France and return to Britain carrying battle casualties. Flying for the first time on 13 June were Women's Auxiliary Air Force Nursing Orderlies whose duty it was to tend the wounded during their passage back to Britain. (IWM CL118)

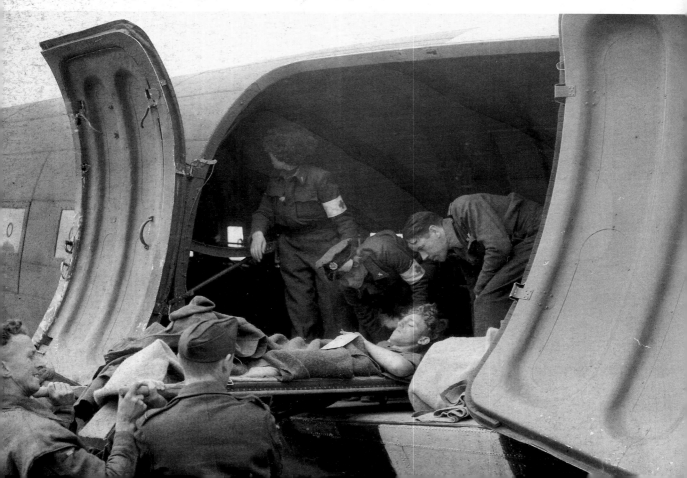

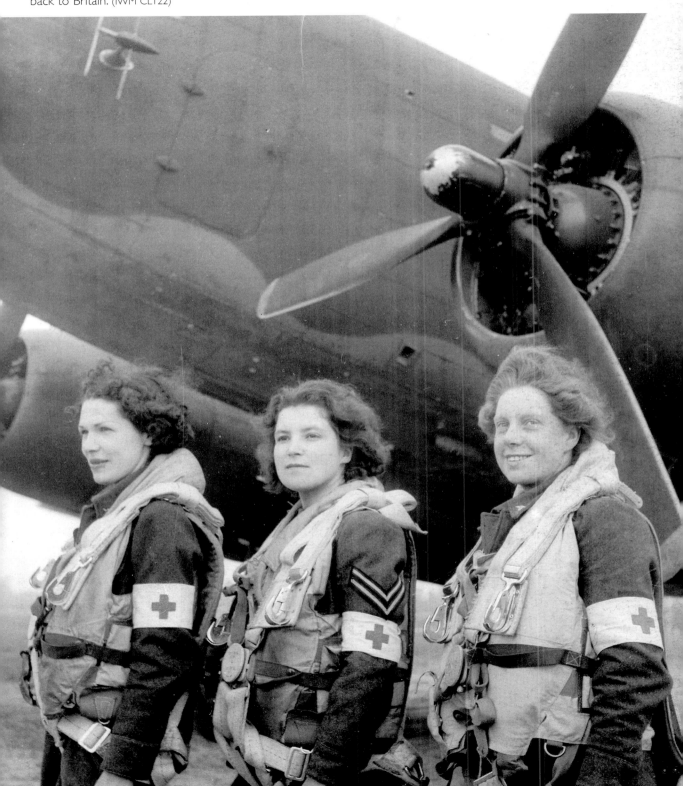

Three Women's Auxiliary Air Force Nursing Orderlies who were flown to France to take care of the Allied wounded to be flown back to Britain. They were identified at the time as from left to right: Leading Aircraftwoman Myra Roberts of Oswestry, Shropshire, Corporal Lydia Alford of Eastleigh, Hants and Leading Aircraftwoman Edna Birbeck of Wellingborough, Northants. They are pictured in France with an RAF Dakota which would take wounded back to Britain. (IWM CL122)

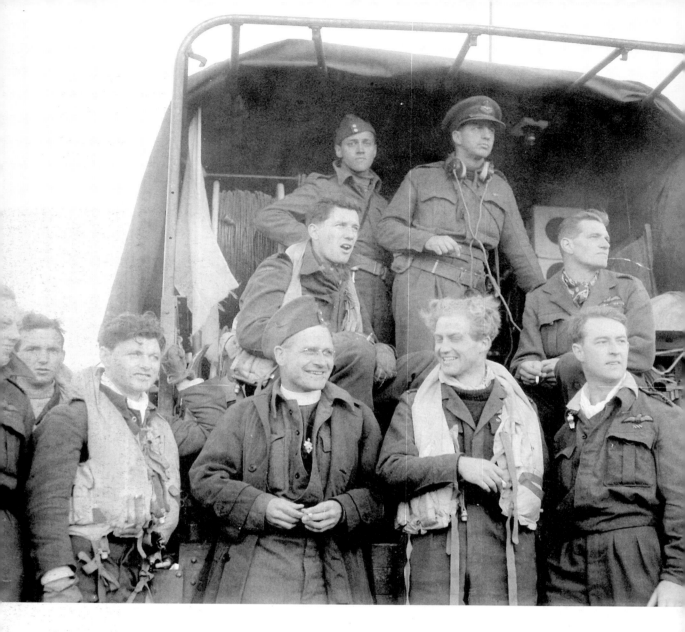

Padre F. R. Lane of Regina, Saskatchewan, chats to pilots at Flying Control on arrival on the first airstrip to be built in France. The pilots are of No. 144 Canadian Spitfire Wing and the airfield is St Croix-sur-Mer. Designated an R&R, Refuelling and Rearming airfield, it was also known as B.3. Seated in the lorry on the right is the fighter ace, twenty-nine year old Wing Commander Johnnie Johnson. These airstrips were primitive and had no buildings although in the case of Johnnie Johnson he had brought a caravan with him from Britain which was looked after by his batman Varley. (IWM CL89)

A Royal Air Force convoy prepares to move through a French Village. After landing in France, RAF ground personnel had to work swiftly to prepare the new invasion airfields for RAF fighters. When the aircraft arrived at their new base the ground crew had to turn the aircraft around, refuelled and rearmed as quickly as possible to ensure that the fighters could maintain air superiority over the invasion area.

The vehicles featured are Bedford QL 3 ton four-wheel drive trucks, the most numerous British military truck of World War II. From 1941 to 1945, over 52,000 were built by Vauxhalls in Birmingham and fitted with a wide variety of bodies serving in many roles. (IWM CL46)

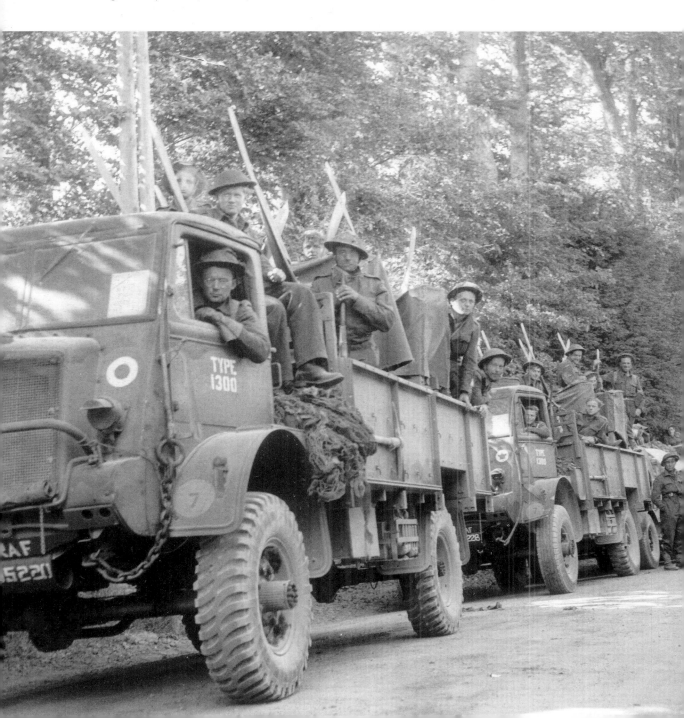

The first Royal Air Force padre on the D-Day beaches, Squadron Leader the Reverend Crawford-Scott RCAF of Hawkesbury, Ontario, talks to a wounded British soldier who is waiting to be flown back to England.

The padre was not always a welcome sight or a comfort to those wounded in battle. The sudden appearance of an officer of the cloth sometimes made the wounded wonder whether their injuries were much worse than they were led to believe and that the last rites were imminent. The reality was that, regardless of the injured's denomination; the padres were there to offer comfort. Note the large label around the soldier's neck which carried his name, rank and number as well as a summary of his injuries in case he fell unconscious or became disorientated.

Despite many difficulties the Reverend managed to bring his church-organ too and reported well-attended services at each RAF and RCAF unit he visited. (IWM CL113)

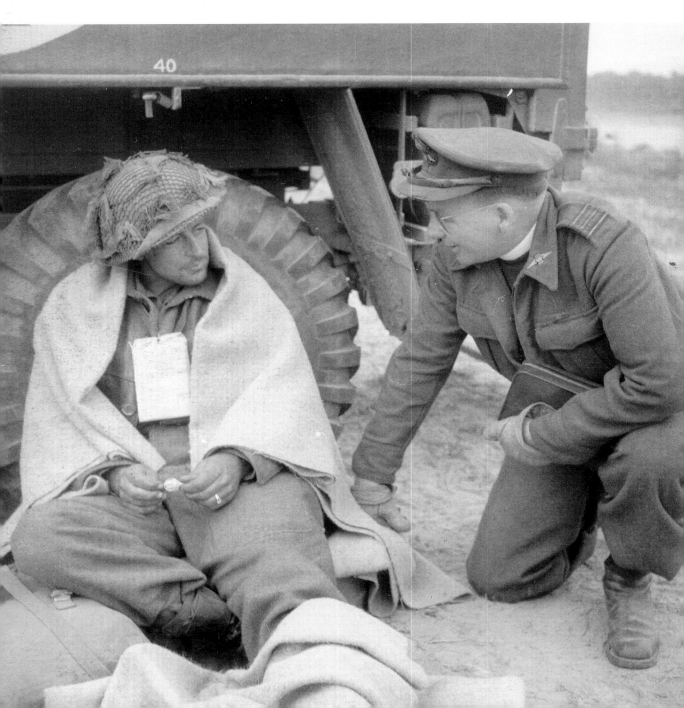

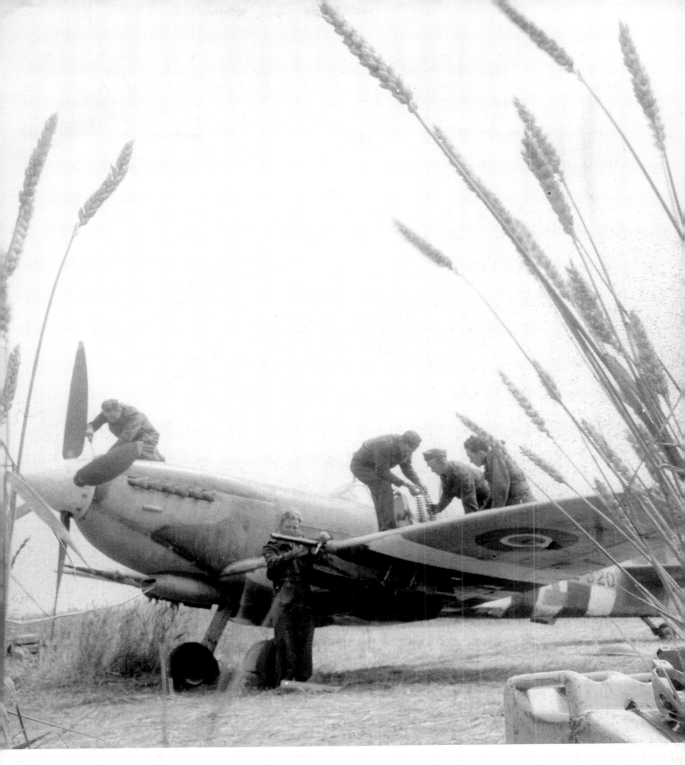

Ground crew working on a 2nd Tactical Air Force Supermarine Spitfire at its dispersal point in a Normandy wheat field. (IWM CL538)

Pictured on 10 June 1944, Wing Commander James Edgar 'Johnnie' Johnson DSO and Bar, DFC and Bar enjoys a piece of chocolate after his arrival in France with 144 Wing (Canadian). The first airfield prepared by Allied engineers was ready for RAF use on 8 June. Johnson, based at Ford in Sussex sent two of his pilots to check that the airfield at St Croix-sur-Mer was ready. On hearing that the airfield was indeed ready for use Johnson led his wing of three Spitfire squadron's flown by Canadian pilots into action over Europe and then to the airfield where RAF 'servicing commandos' had the Spitfires refuelled and rearmed in just twenty minutes. This was still a high-risk area – the Luftwaffe remained a significant threat and artillery barrages from enemy positions, mainly at night, were a major problem. German snipers were operating and minefields were the norm, not the exception, near the beachhead. These airstrips were primitive and had no buildings, although in the case of Johnnie Johnson, he had a personal caravan. Johnnie Johnson went on to become the highest scoring British fighter pilot of World War II. (IWM CL104)

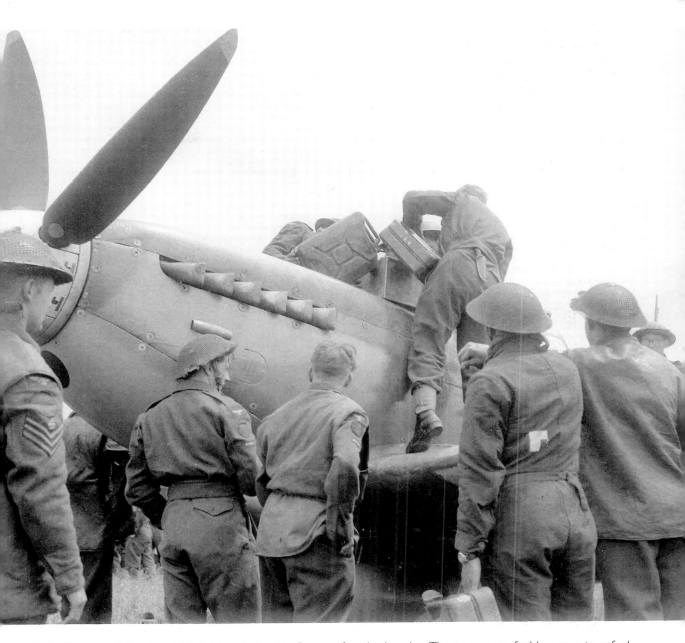

Refuelling one of the first RAF Spitfires to land in France after the invasion. There were no fuel bowsers to refuel the pioneering RAF fighters and the fuel had to be 'hand-poured' via scores of jerry-cans stockpiled from the first day of the Allied invasion. Time was of the essence, not only to ensure adequate air cover for the ground troops but also to remove the tempting target of a 'dry' Allied fighter to German troops nearby. (IWM CL75)

Part 4
Moving Inland

Allied troops enter Avranches. Once US forces under General Omar N. Bradley had cut off the Cotentin peninsula and captured Cherbourg, the Americans then headed south. After fierce fighting in easily defendable bocage terrain, on 18 July US troops captured Saint-Lô, a vital communications centre, effectively cutting off the German force commanded by Field Marshal Erwin Rommel. Bradley's US 1st Army was joined by the US 3rd Army under General George S. Patton and broke through the German left flank at Avranches, enabling the Americans to race into Brittany and also south to the Loire and around Paris. A German counter-attack at Mortain attempted to cut-off part of Patton's army but failed and the Germans began their withdrawal to the Seine. (IWM EA31840)

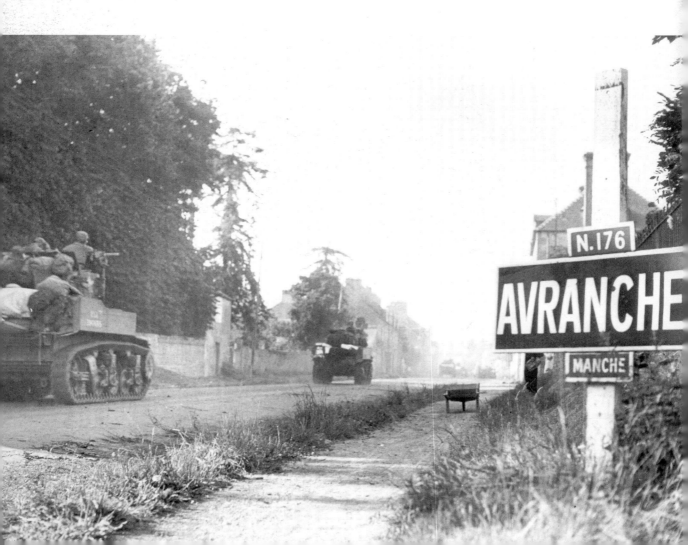

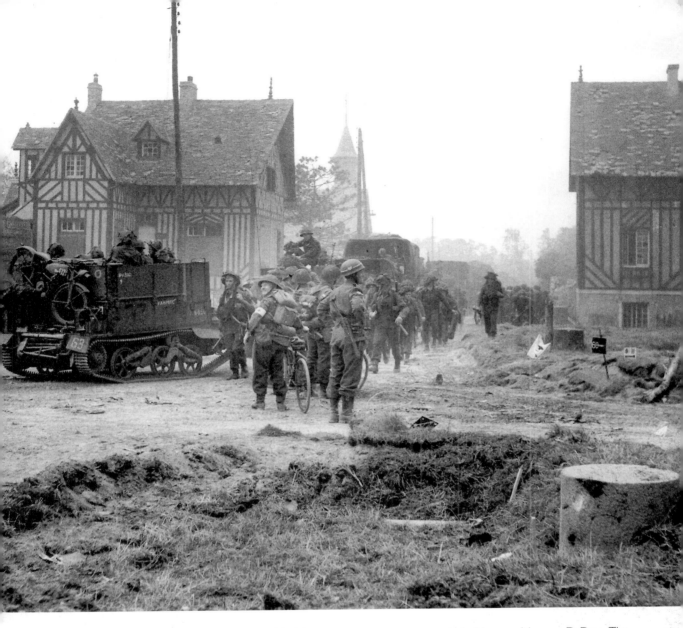

A convoy of troops and vehicles of the 13/18th Hussars pause at a crossroads in Lion-sur-Mer on D-Day. The photograph was taken by a Sgt Mapham. Note that the routes out of the town have already been signposted by British army advance units. Despite this, there seems to be some hesitation as to which route to follow – German resistance may be holding up the column's advance. The vehicle in the foreground, carrying a motorcycle and troops, and bearing the name *Vampire* is a Carden-Loyd Universal Carrier. This British vehicle was developed in the late 1930s from a family of infantry carriers and remained in production until 1945 by which time around 35,000 had been built. The Carrier was also manufactured in New Zealand, Canada, Australia and interestingly in the US as the T16. The Carrier was developed to transport infantry, and particularly, a Bren gun and its crew, through areas where small arms fire was intense. Although the Bren carrier model was only one version of the type, the vehicle was known in the Army as a Bren Gun Carrier. (IWM B5041)

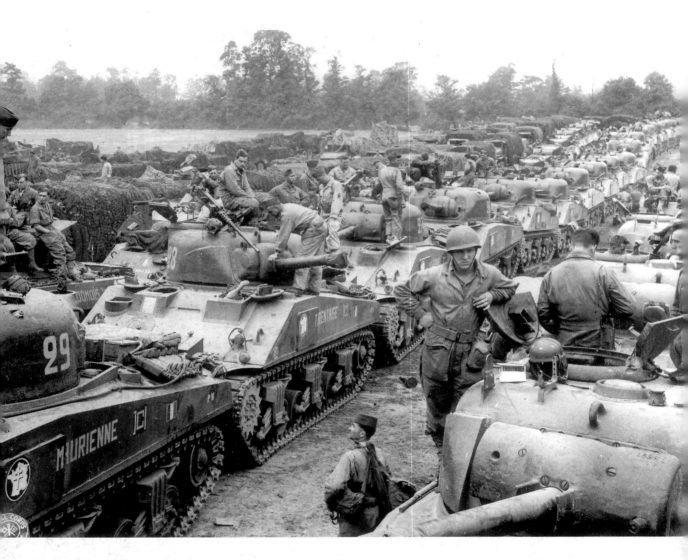

Troops of the 2nd French Armoured Division clean and mount the guns on their American-built Sherman tanks at a marshalling area in France just after landing in Normandy. Fully equipped with US equipment, The French Army participated in the liberation of France, the 2nd French Armoured Division being among the troops given a leading position when the Allies entered Paris.

Compared to the generally superior German tanks, the Sherman possessed two basic advantages: reliability and simplicity. The latter made it possible to manufacture them in great numbers – over 49,000 Sherman tanks were built during World War II, more than the combined British and German tank output of the war. (IWM EA32615)

This inverted German tank shows the fire power of the RAF Typhoon. Impressed by the power of the RAF's rocket Typhoons, US Army chiefs offered the RAF an ideal rocket target south-east of Coutance where the Germans had massed considerable armoured strength. RAF Typhoon units of 2nd Tactical Air Force responded enthusiastically and by the end of a day of shuttle missions had claimed more than 30 tanks destroyed as well as other vehicles. Three days later when US forces overran the Typhoons' target area US intelligence officers checked the masses of wrecked German armour and officially credited the RAF with 50 tanks. In effect they had accounted for about half a German division. (IWM CL630)

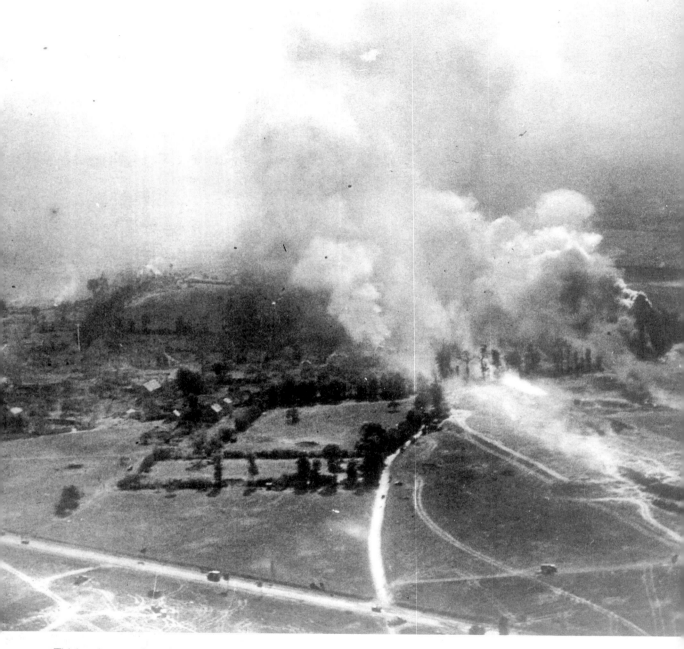

Thick columns of smoke and fire from bombs released by Royal Air Force Halifaxes and Lancasters in an air raid on the German positions at Falaise in which 1,000 bombers took part, 17 August 1944. (IWM HU52367)

The Typhoon was a very rugged aircraft which could take a great deal of damage. It is however unlikely that the designers ever thought it could take this much and bring its pilot home so he could have his photo taken. JR427 was a Gloster built Typhoon IB. The aircraft probably sustained the damage during a low-level attack when an exploding target almost brought down its attacker too. Look how rough and ready this front line aircraft is, quite apart from the battle damage.

Fighter bombers were used to attack enemy shipping in the English Channel and ports as well as airfields and 'targets of opportunity'. It was the discovery of the V-1 launching sites that required a concentrated attack by the fighter bombers. Normally crossing the channel at zero feet the aircraft used to race across the French countryside until close to the site. A steady climb was then made to about 10,000 feet before diving in to release the bombs at an angle and then hurriedly depart the scene.

After the invasion of France the rocket projectile was used to great effect on the enemy. Whole wings (four squadrons) of rocket firing Typhoons roamed the countryside attacking any enemy movement. By firing their rockets at the beginning and end of a military convoy they blocked all escape, and then further attacks could annihilate the concentrated vehicles of the enemy. 20 mm cannon was devastating against soft skinned vehicle while the tanks remained impervious to anything except a direct bomb hit. (IWM CL852)

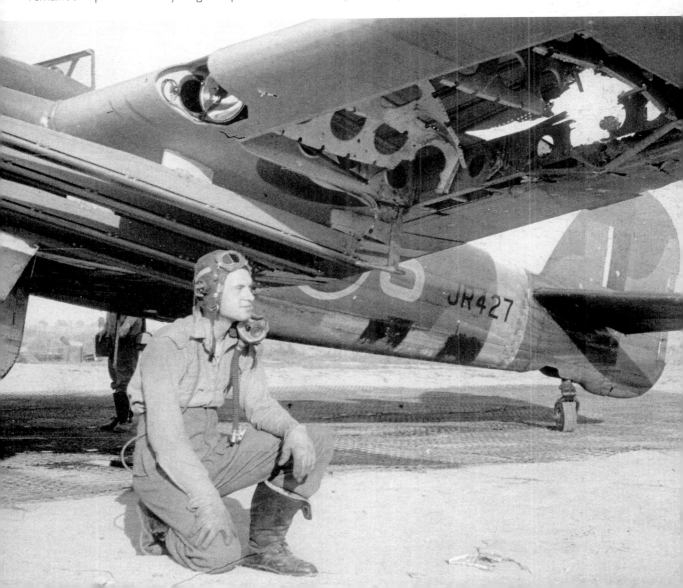

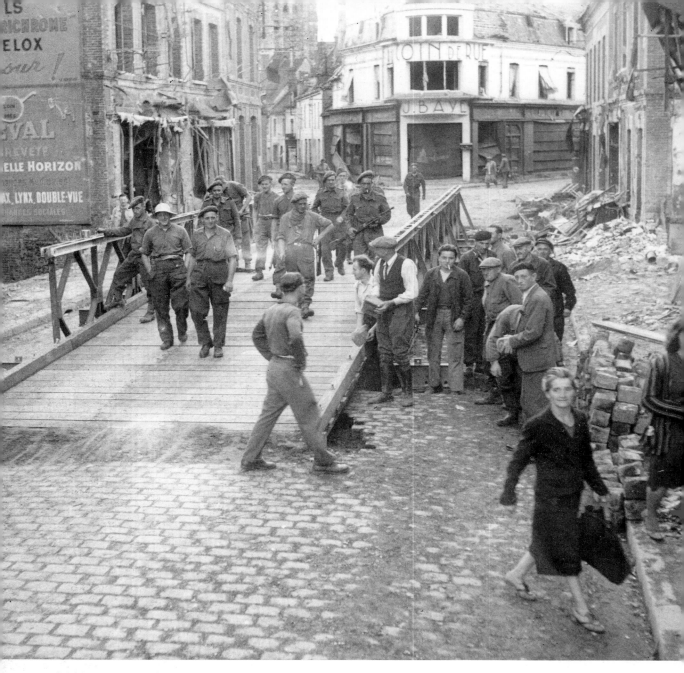

British troops and French civilians make use of one of World War II's most ingenious inventions, the Bailey Bridge. Developed by Briton Donald Bailey in late 1940, the Bailey Bridge was a portable (all parts would fit on a three-ton truck) pre-fabricated bridge which could be used to reinstate or create road or river crossings. Around 1,500 of these bridges were built by the Allies post D-Day so their progress would not be hindered. Bridges sabotaged by retreating German forces or damaged in battle or by air attack were quickly replaced. Bailey Bridges could span gaps of up to 200 feet, required no special tools for assembly and were strong enough to carry tanks. The bridges were manufactured in the US as well as in Britain and continue to be made and used for military and civil uses the world over. (IWM B9650)

A German PzKpfw Panther battle tank, abandoned by its crew, sits among the ruins of a Normandy town. The Panther tank was inspired by the T-34 in that it was first developed to counter the Soviet tank and incorporated many of its features. The Panther's 75mm gun could punch a hole through 120mm armour at a kilometre's distance. The tank was also well protected at the front which enabled it to take on Allied tanks from a distance with relative impunity. It was thought by the US Army that five of their Shermans were needed to take on and destroy one Panther. During the last two years of the war, more Panthers(3,900) were made than any other German tank. (IWM CL696)

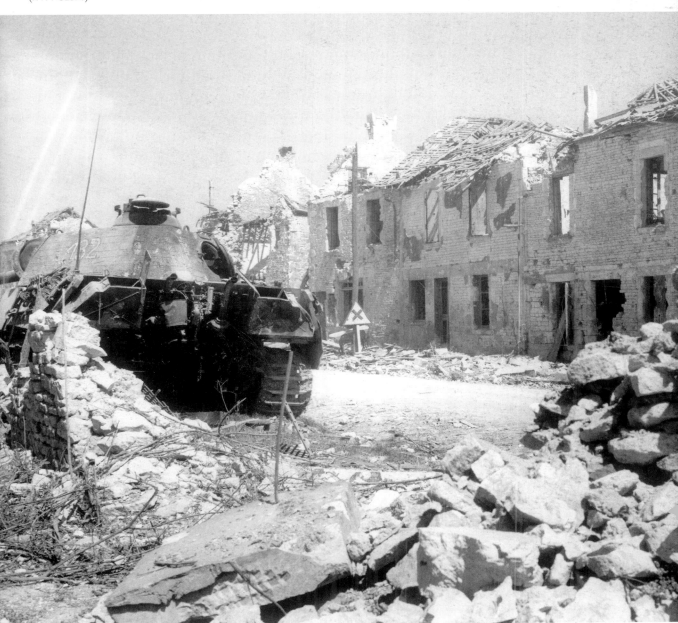

Leading Aircraftman Cresswell of Malden, Surrey, hands over a film magazine to Leading Aircraftman H. Wadlow of Teignmouth, Devon, at a mobile darkroom attached to a Royal Canadian Air Force squadron in Normandy. Over 4,500 photoreconnaissance flights were undertaken prior to the Normandy landings. This gave Allied planners detailed knowledge of the terrain as well as enemy positions. Photographic interpreters could readily identify armour and gun emplacements as well as estimate troop numbers. While the landings were underway, reconnaissance aircraft recorded the actions below and continued to do so as the Allies progressed through France. Swift processing of reconnaissance film was essential so that commanders could have the freshest intelligence possible. (IWM CL179)

Lieutenant Peter O. Benson points out some of the features of a German Nebelwerfer, to Sergeant Harry Kurczewski. The rocket launcher was known as the 'Screaming Meemie', easily recognised by its screeching rockets. The Germans booby trapped abandoned equipment and bunkers as they fell back in front of the Allied advance. (USA 10249)

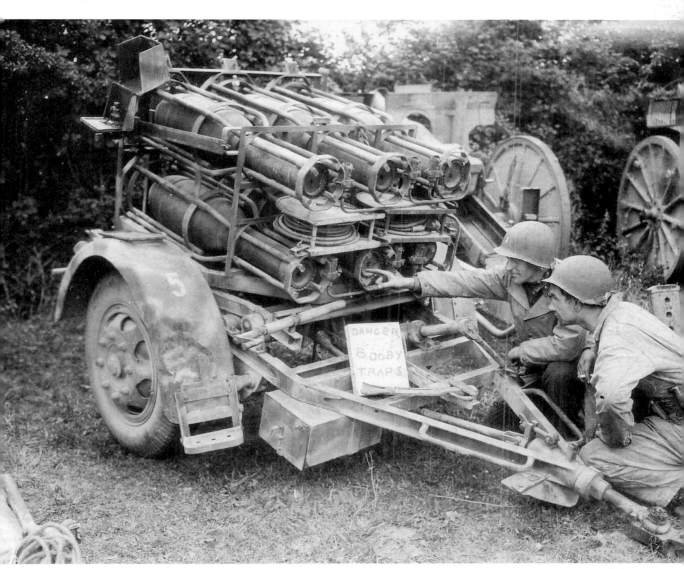

French civilians toast the Royal Air Force at a small Normandy café. From left to right are Corporal W. Robinson of Welby near Grantham, Leading Aircraftman J. Grafton of Barrow-in-Furness who was in action on a Bren gun on a tank landing craft shooting down flares off the French coast before landing, Corporal J. Brown of Dundee, Corporal G. Goodall of Leek, Staffordshire, Leading aircraftman W. Shields of Whitley Bay, Northumberland and Corporal J. Haddow of Leicester. (IWM CL93)

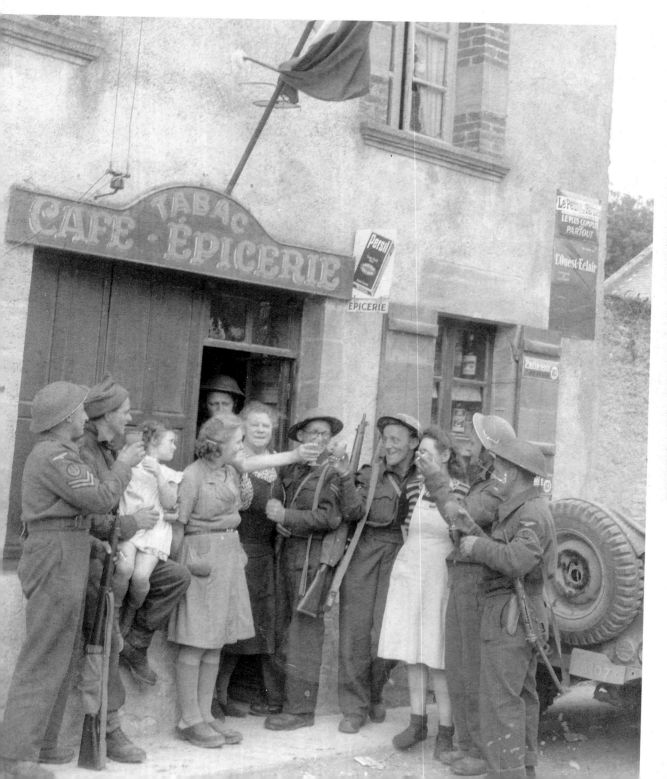

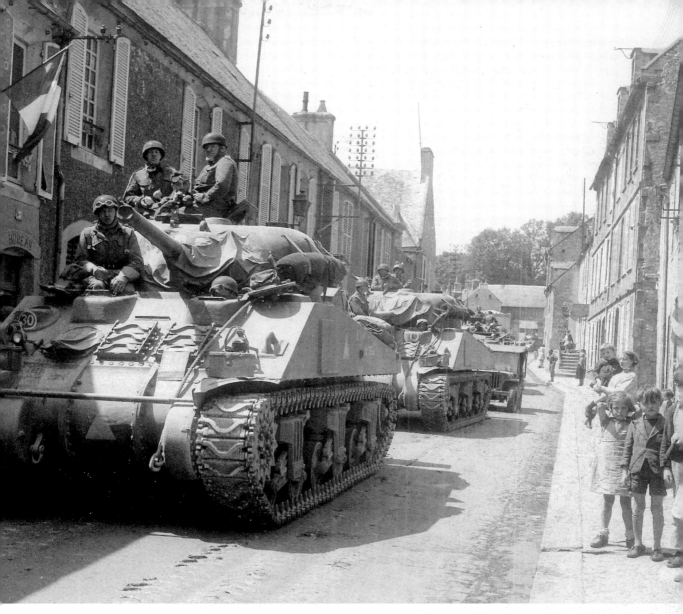

British Sherman tanks passing through Bayeux on 7 June 1944. Bayeux had been the objective identified for the troops landing on Gold beach on D-Day. Although they did not take it on D-Day, the British Army were within a mile and half of the historic city by the end of the day and early next morning the city fell to the Allies. Bayeux was the first French city to be liberated by the Allies and the inhabitants gave the British a most enthusiastic welcome throwing flowers on the liberators' tanks.

The American main battle tank of World War II was the Sherman. It was a medium tank weighing 35 tons and was armed with a 75mm gun capable of punching through 3.7 inches of enemy armour at a range of 500 yards. The Sherman had an effective armour thickness of 2.8 inches in the front, 1.6 inches in the sides, and 1.4 inches to the rear. It carried a crew of five, three machine guns and a smoke mortar. By D-Day, the Sherman with its high profile and comparatively weak armour and small gun was a poor match for the German tanks against which it fought. The Sherman's gun could not kill Panther or Tiger tanks in a head-to-head encounter, even at close range. The German tank guns were more powerful than the Sherman's and could penetrate the Sherman's frontal armour even at long range. (IWM B5685)

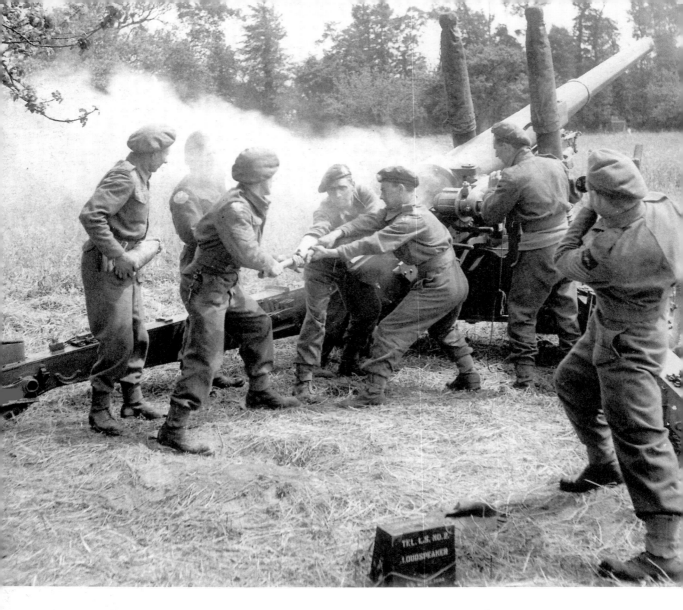

A British 4.5 inch gun being primed ready for firing by artillerymen during the holding operation before the push to Caen. Note the mobile loudspeaker in the foreground. Due to the extreme noise levels during artillery barrages, the NCO (right) known as Number 1 of the gun, acknowledged orders from the GPO (Gun Position Officer) using the tannoy system.

The 4.5 inch gun was intended to succeed the 60-pounder while having a greater range than the 5.5 inch gun. Production did not begin until late 1940, and the first guns were issued in 1941. The gun was identical to the 5.5 in all respects except calibre. The weapon was not as popular with the Royal Artillery as the 5.5 inch because the extra range was not viewed as enough to compensate for the lighter shell. The 4.5 had a rate of fire of two rounds per minute but not for prolonged firing while the maximum range was 20,500 yards (18,758 metres). (IWM B5452)

Seven Squadrons equipped with Auster aircraft were allotted to the 2nd Tactical Air Force. As the invasion forces moved inland many of the Squadrons split into Flights and occupied hurriedly made airstrips to fly reconnaissance missions and then direct fire for the artillery or guide RAF Typhoons to their targets. It was a hazardous existence, since the aircraft were unarmed and vulnerable to attack from enemy fighters and ground fire. They relied purely on outmanoeuvering any attackers and sometimes also the shells from the guns they were directing.

These two photographs show a typical operational Air Observation Post (AOP) landing strip in July 1944. (PC2 and PC3)

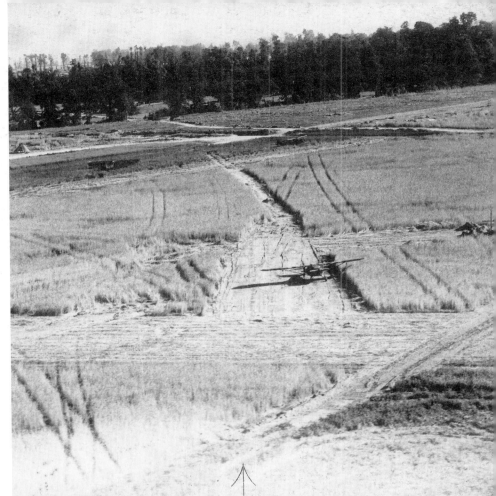

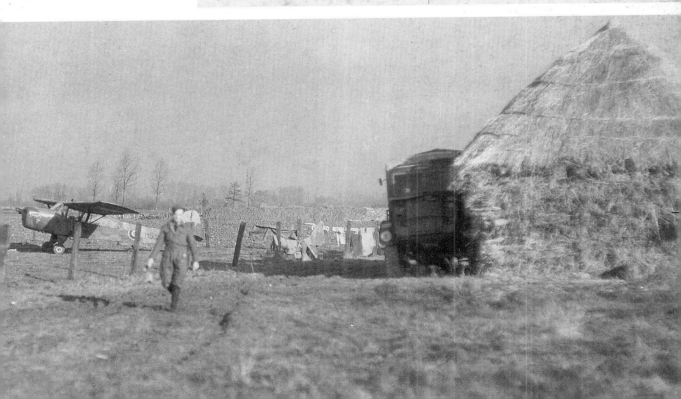

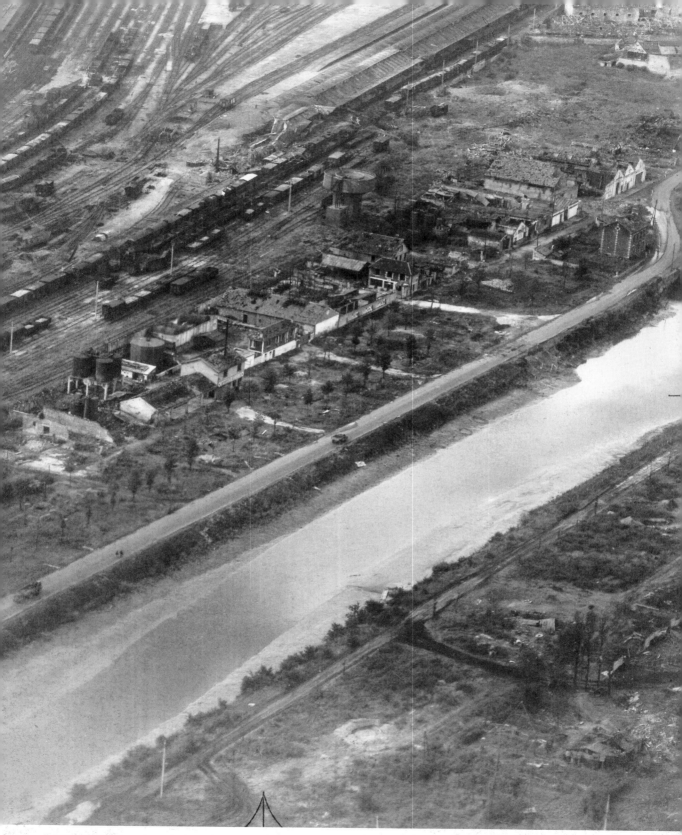

These two reconnaissance photographs were taken by a low-flying Auster aircraft in July 1944. The AOP proved of great service to the troops in the field throughout the campaign. (PC4 and PC5)

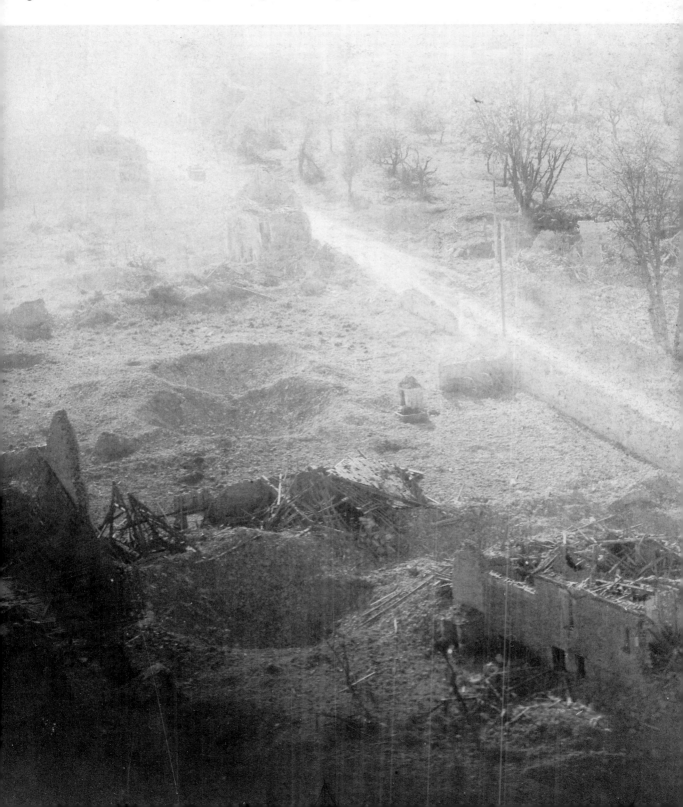

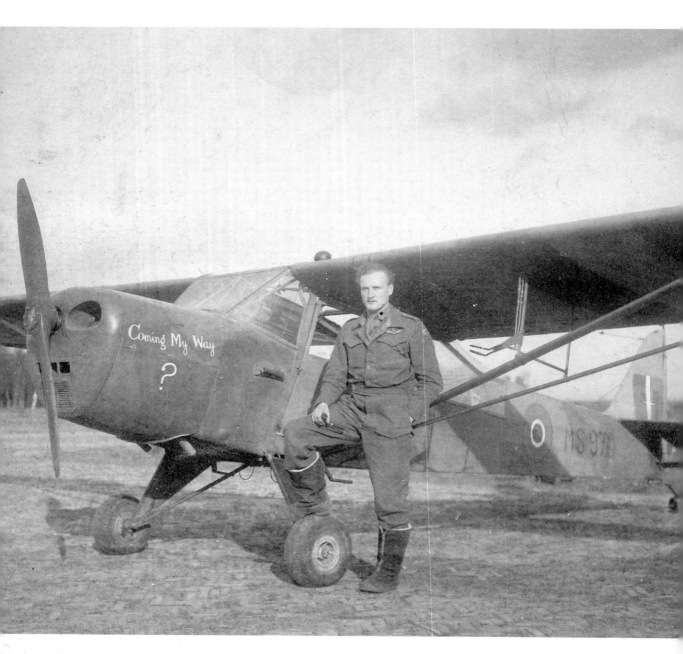

Air Observation Post pilot Captain Ray Coles, DFC, of 653 Squadron, 83 Group, 2nd Tactical Air Force with his Auster Mk IV christened 'Coming My Way?' – a question for the Allied ground troops as he flew low out over the front line to locate enemy tanks and artillery. (PC1)

A US field artillery unit pours a hail of fire into enemy lines on the St Lô sector during the night-time bombardment which preceded the final armoured and infantry assault on St Lô. (IWM EA30190)

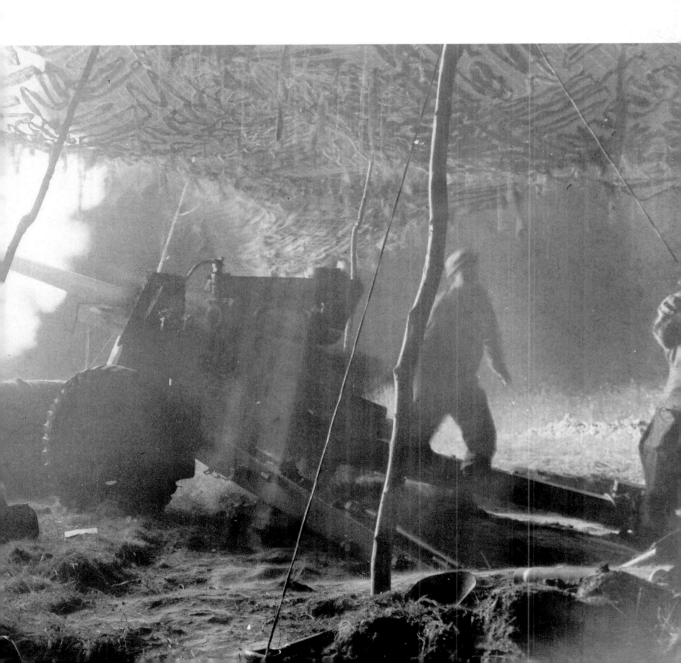

Leading Aircraftman C.C. Strong of Ontario, Canada, at work on a damaged fighter. The first Royal Air Force Repair and Salvage Unit was working operationally within three days of landing on the Normandy beach. The unit, composed of both RAF and Royal Canadian Air Force personnel, was tasked with the repair of aircraft shot-up in combat or damaged on landing. Within thirty-six hours of being established, the unit was able to return five damaged Spitfires to their squadron ready for action again. Without these units the aircraft would have been adandoned, scrapped, stripped for spares or shipped back to the UK. (IWM CL185)

Leaving a cloud of dust behind them, American armoured forces race through Luce-sous-Ballon in pursuit of retreating enemy forces. German forces were ordered to withdraw on 16 August but many had been trying to fall back to the Seine since 14 August, their leaders attempting to salvage what was left of their armoured divisions. The Americans and French closed in from the south, while the British to the west and the Canadians and Poles to the north continued to close the net. On the morning of 21 August, the Falaise gap was closed by the Allies. (IWM EA34030)

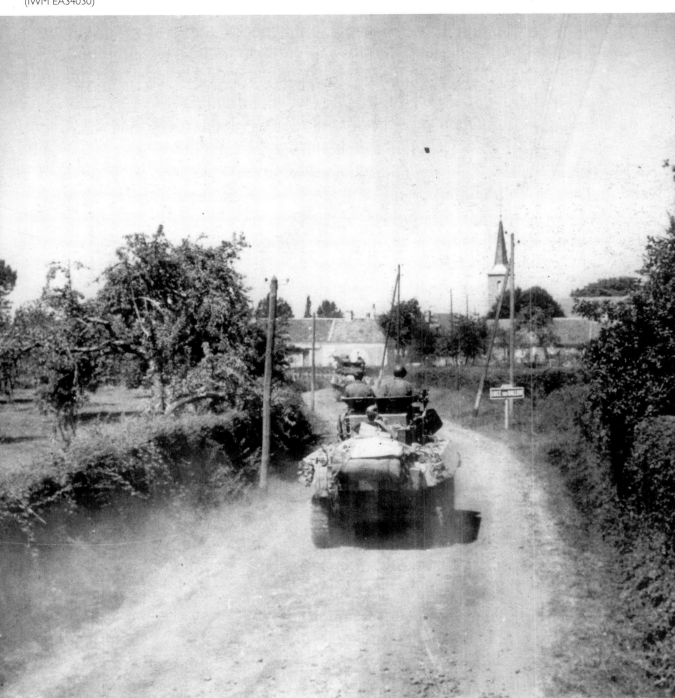

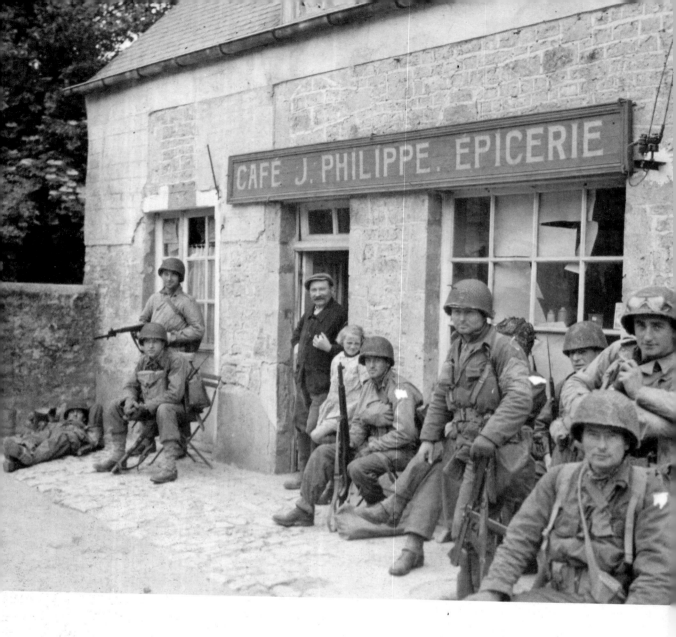

Troops take a well earned rest as they push inland. Most of the unit have bayonets fixed which implies the close proximity of German troops. (USA 252684)

Three Royal Canadian Air Force pilots take time out and try to control a more basic form of horsepower than they are used to. The horses were left behind by the retreating Germans. The men are from left to right, Flt. Lt. Kenzie of Montreal, Flt. Lt. P. Logan of Montreal and Flt. Lt. J.D. Lindsey of Armprior, Ontario.

Canadians played a key role in the Allied landing and subsequent campaign. Of around 150,000 Allied troops who landed or parachuted into the invasion area, some 14,000 were Canadian. The Royal Canadian Navy contributed 110 ships and 10,000 sailors for the landings while fifteen RCAF fighter and fighter/bomber squadrons helped patrol the sky over Normandy and attacked enemy targets. (IWM CL191)

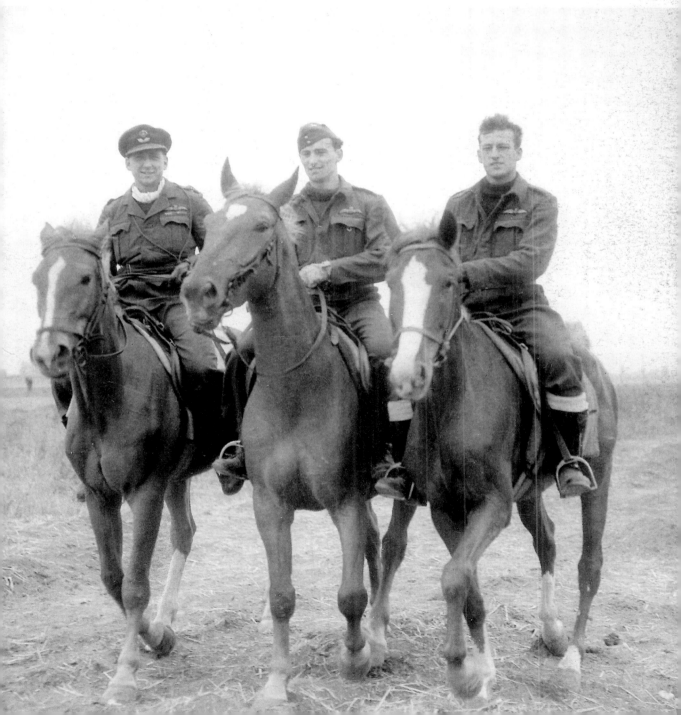

British troops in the widely used Universal Carrier pass by an abandoned German PzKpfw (Panzerkampfwagen) IV medium tank. The majority of these tanks in service in Normandy were of the Ausf H version.

It is interesting to note the two techniques used for additional frontal protection of the two vehicles. The tank carries spare tracks as a means of increasing the thickness of protection on front while the Carrier is carrying its own sandbags to protect the crew. Also note the American star painted on the side of the British vehicle – all Allied vehicles carried the white star insignia for swift identification to avoid 'friendly fire' incidents but there appeared to be no hard and fast ruling about the star's use. (IWM CL843)

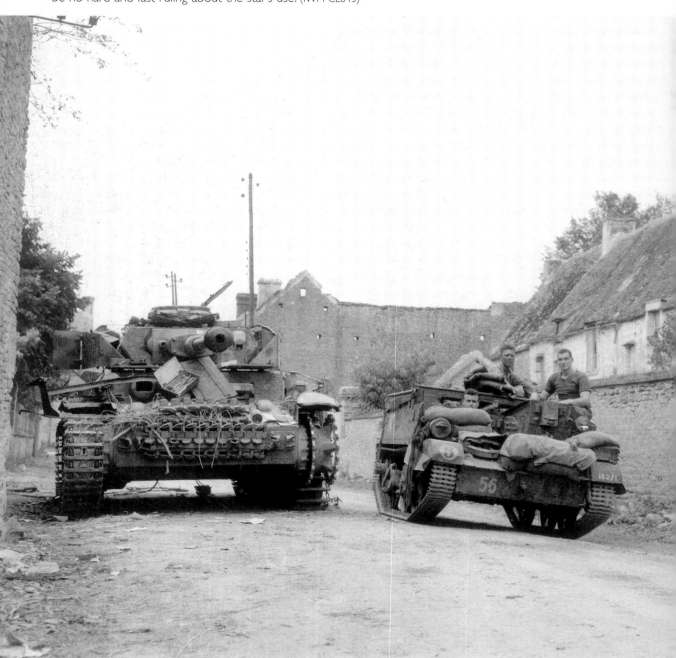

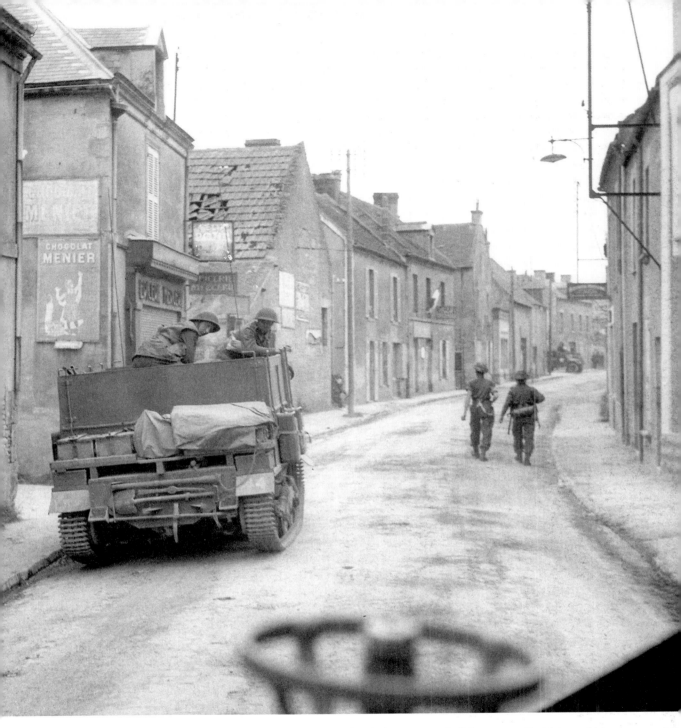

An infantryman's view of a French town as British troops make their way past buildings, any of which could have contained hazards such as snipers. It is interesting to note the French tricolor hanging from the building on the left in the distance, the resident proud to proclaim his national pride within the safety provided by the liberators. (IWM B5019)

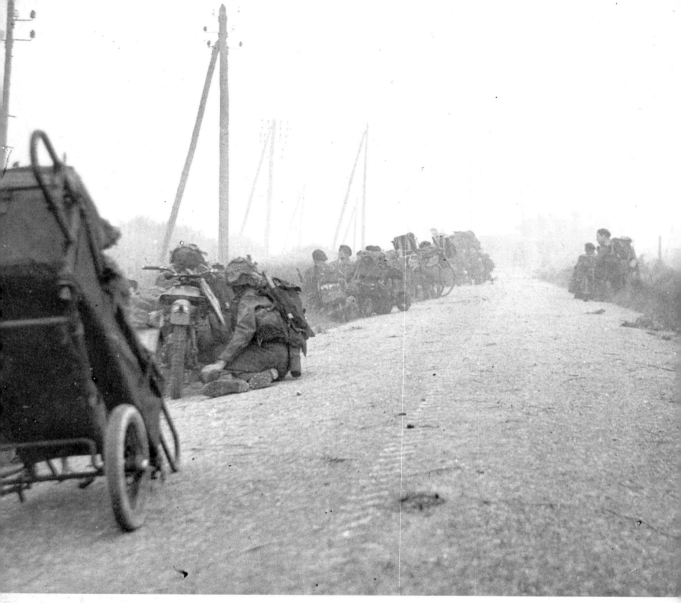

Canadian infantry wait in the ditches with their bicycles as men of the 48th Royal Marine Commando (4th Special Service Brigade) take cover from mortar fire on the roadside on 6 June 1944. On the first day, the British and Canadian division made a rapid advance inland but failed to take Caen, which had been their initial objective.

Aerial bombardment of Juno Beach in the days leading up to D-Day caused no significant damage to German fortifications. The naval bombardment, from 0600 to 0730 included everything from battleship big gun barrages to fire from tanks and artillery sitting on transport ship decks and landing craft. It only managed to destroy 14 per cent of the German bunkers guarding the beach. Because of bad weather delays the Germans had half an hour to reform between the end of the bombardment and the landing of Canadian troops on the beach.
(IWM B5221)

In the streets of Cherbourg, a bridge lies wrecked by Allied bombing prior to the fall of the city. The first British to enter Cherbourg were four Royal Air Force members of an embarkation unit who entered the town with US troops.

After heavy bombardment followed by fierce street fighting, Cherbourg was captured by the Americans on 27 June. The Germans had pasted up posters around the town saying 'Assassins always return to the scene of their crime' referring to the capture of Cherbourg in 1418 by the British who held it until 1450. (IWM CL255)

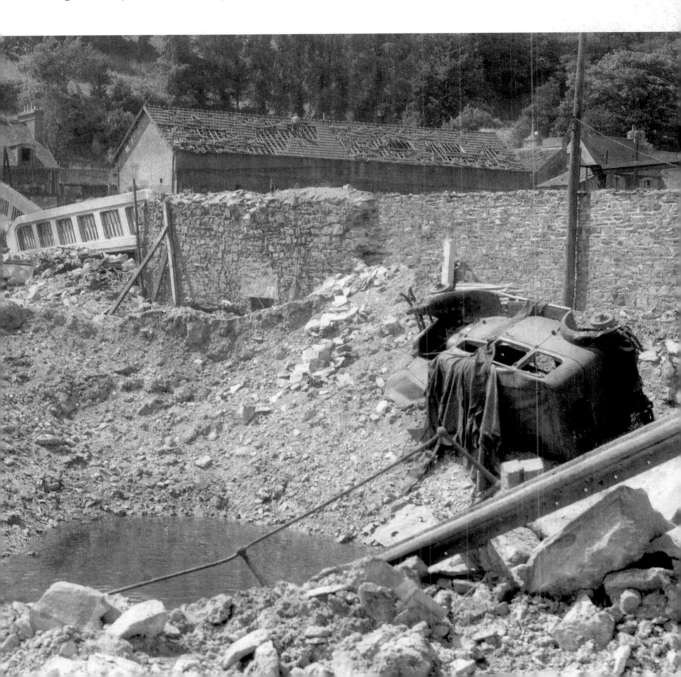

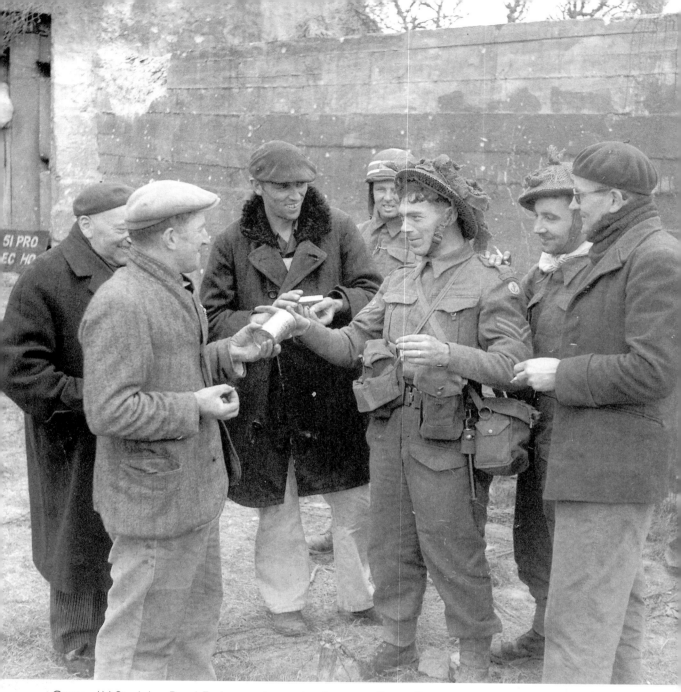

Corporal V. Stockden, Royal Engineers, gives a tin of cocoa milk to villagers of Ver-sur-Mer, 7 June 1944. Note the shrapnel and shell damage to the wall in the background which seems to be part of a German fortification. At that time it was in use as the Sector HQ of 51 PRO, a unit of the British Military police.

The village, a mile inland, was liberated on D-Day. By the end of the 'longest day', the British 86th Field Regiment having landed on Gold beach at H Hour plus 90 minutes was installed at Ver-sur-Mer. Equipped with self-propelled 25-pounder field guns the men of the 86th had approached the Normandy beach with their guns blazing while still on their landing craft.

By D-Day plus 1, the infantry that the 86th supported had created a beachhead that reached eight miles inland and was seven miles wide. (IWM B5253)

Residents of Avranches stop to watch vehicles of a US armoured unit move through the street on 31 July 1944. Some of the destruction caused by the shelling of the town prior to its capture can be seen in the background. By 12 June the invasion beachheads were joined and Allied troops were able to forge inland on a broad front and Cherbourg surrendered to the Allies on 27 June. American forces then swung south and after difficult fighting in easily defendable hedgerow country, on 18 July they captured St-Lô, a vital communications center, thus cutting off the German forces under Rommel. Patton's US 3rd Army joined the battle and broke through the German left flank at Avranches. (IWM EA31981)

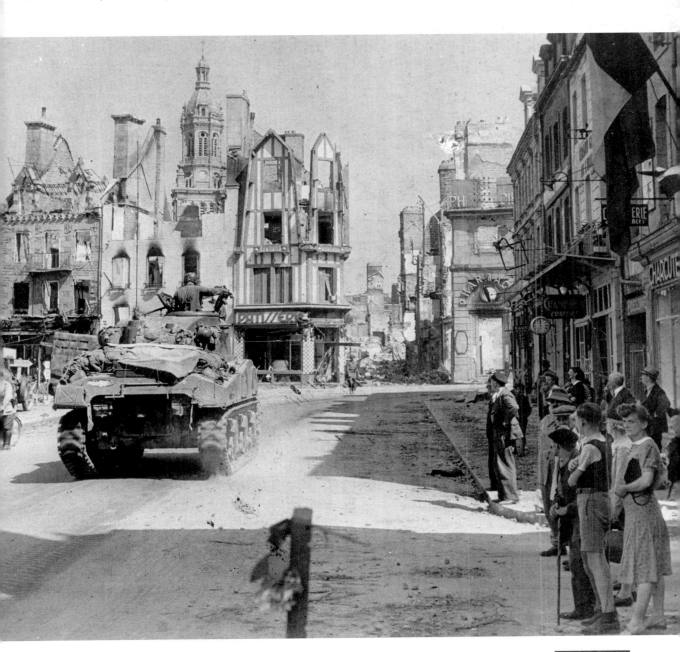

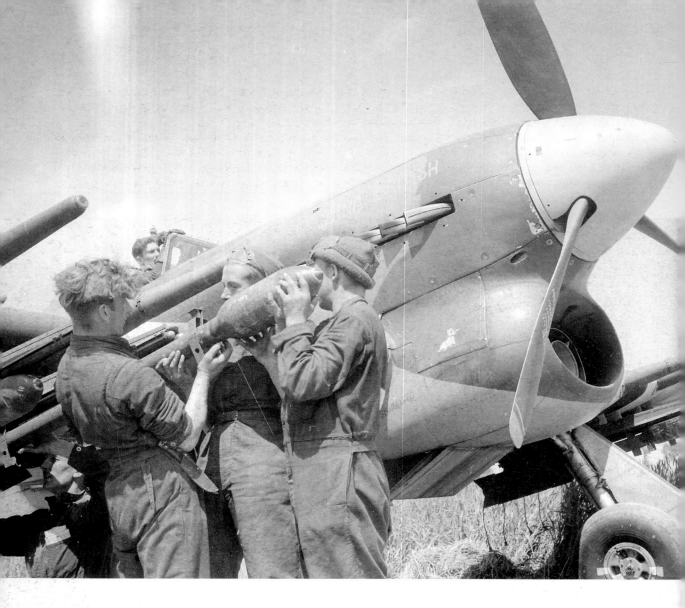

A Typhoon is rearmed with rocket projectiles (RPs) in a Normandy field. The aircraft is one of No. 247 China-British squadron's – note the 'China British' legend on the cowling and the partial 'ZY' squadron codes visible beneath the wing. No. 247 was formed in 1918 as a flying boat unit. In January 1943 the unit began to relinquish its Hurricanes for the new Typhoon. No. 247 joined the newly formed 2nd Tactical Air Force during the summer of 1943 and went on to take part in sweeps over northern France. In April 1944 the squadron was trained in the use of the devastatintg RPs and on 20 June the unit began to operate in Normandy, principally from the B6 airstrip at Coulombes. (IWM CL157)

A French farm cart passes smashed German armour and transport just outside Roncey. The French countryside was ravaged by the ferocity of the actions on D-Day and the subsequent Normandy campaign. Months of intense Allied bombing followed by naval barrages, aerial ground-attack sorties and then the land battles took their toll on Normandy. This picture shows civilians trying to carry on as normally as possible as a US convoy, led by a motorcycle outrider, approaches. This photograph shows five wrecked German vehicles destroyed by Allied action, probably from the air. All vehicles in the way of the movement of Allied troops or supplies, be they German wrecks or Allied breakdowns, were to be moved immediately or were bulldozed out of the way – progress could not be impeded. (IWM CL633)

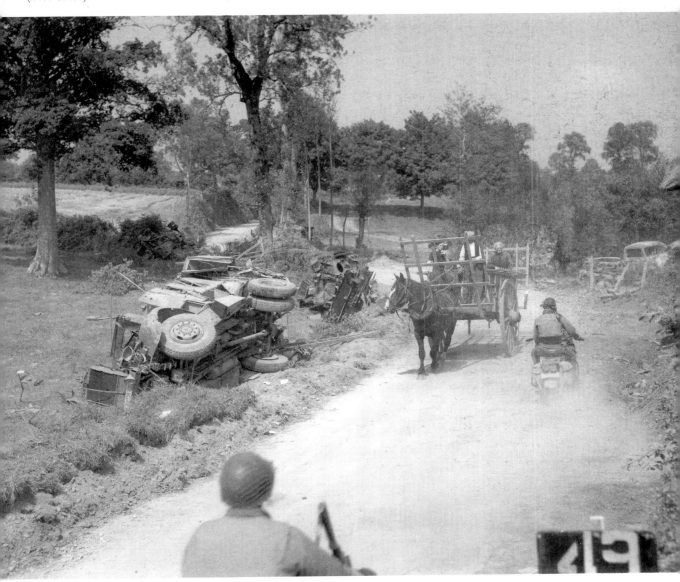

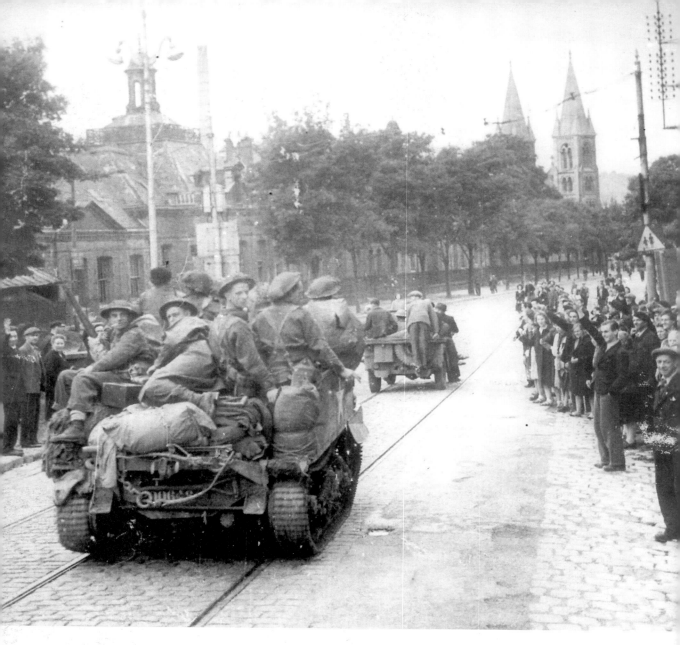

British troops are welcomed by the inhabitants as they enter a French town. Notice that both vehicles are carrying civilians. After four years of German occupation the liberators received the warmest of welcomes as they worked their way through France. (IWM HU90143)

British servicemen with French children near Bayeaux. Many friendships were made amidst the bloody campaigns and some British soldiers 'adopted' French children, keeping in touch with them over the years. Sixty years on, veterans in sadly ever decreasing numbers continue to return to 'their' part of Normandy where they remember fallen comrades and their part in the 'longest day'. Veterans are welcomed as heroes. (IWM B5383)

RAF and Royal Canadian Air Force personnel take a drink with some welcoming French civilians. The RAF Flight Sergeant in the foreground has two interesting points to note. Firstly he is carrying a handgun in a holster indicating that he felt in need of self-defence. An Allied pilot landing amongst retreating enemy troops would not necessarily have been welcomed. His footwear is also worth examining. It is of the sort developed for British aircrew who may have to bale out deep inside enemy territory. The bottom shoe part was all leather and with the aid of a razor blade from the standard issue escape kit easily detached from the suede-finish leggings element of the boot. An escaping airman in civilian clothes but wearing flying boots would not have got very far. (IWM CL269)

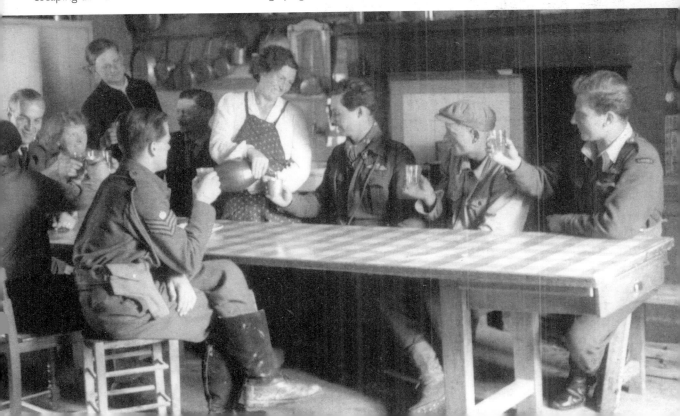

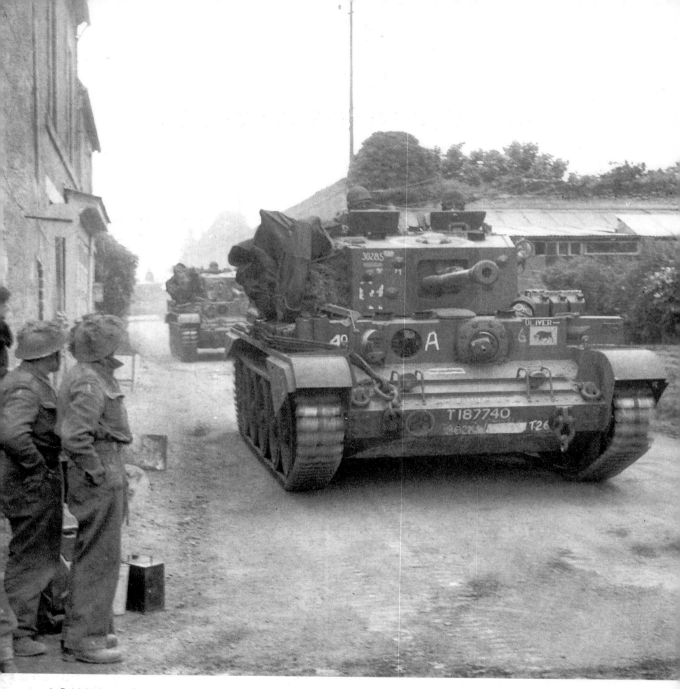

A British Army Cromwell tank named *Oliver* passes British troops in a Normandy town. The tank bears the black bull insignia of the 11th Armoured Division which formed in March 1941. The Division landed in Normandy a week after D-Day and fought through France, Belgium, Holland and into Germany. It liberated Belsen and ended the war at the border between Germany and Denmark.

Notice that both turret crew on the tank have large map boards in front of them indicating that it is a command tank. The Cromwell entered British Army service in 1942 but did not see action until the invasion of Normandy. It was the tank's manoeuvrability and speed rather than its firepower that enabled it to handle heavier German tanks. The Cromwell was the most significant British cruiser-gun tank of the war and remained in British Army service until 1950. (IWM B5557)

Part 5
Sustaining the Advance

An American patrol hugs a hedgerow by the side of a lane near St Lô as German artillery shells burst overhead. At this point the Germans were using the fire from gun emplacements south of the town. St Lô fell to the Americans after an eight-day siege. (IWM EA30511)

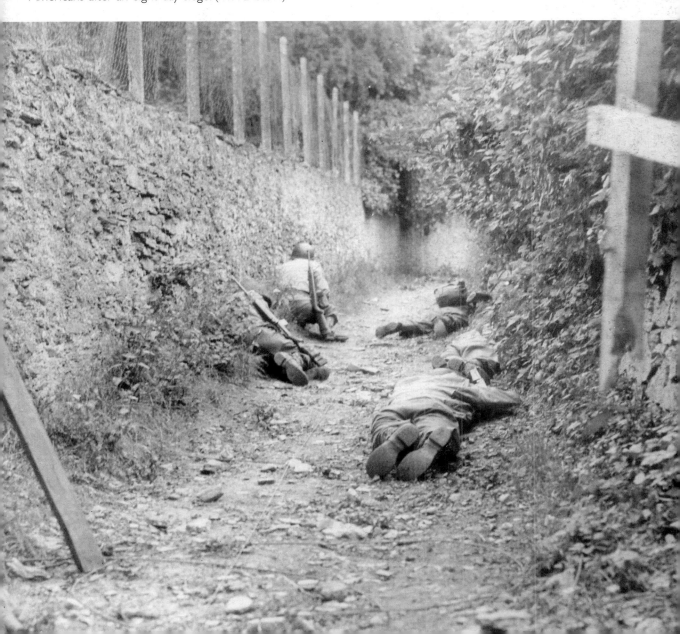

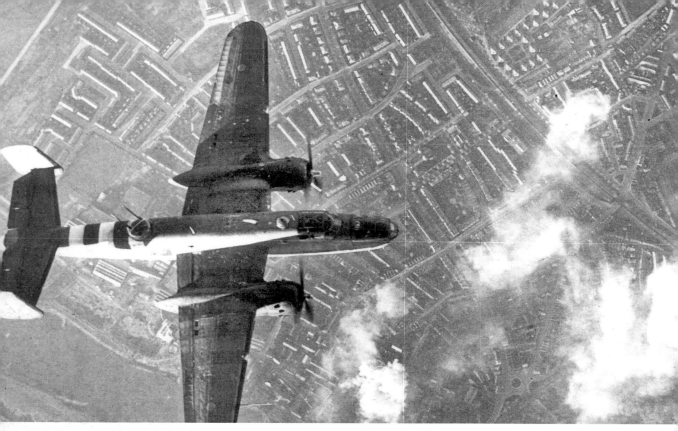

Medium bombers of the 2nd Tactical Air Force scored a success of major importance on 28 October when they attacked and destroyed a large road bridge over the Maas at Roermund. Crews saw at least three sticks of bombs strike the centre of the bridge which collapsed. Seen here is a North American B-25 Mitchell flying over the target during the attack on a rail bridge at Deventer, eight miles north of Zutphen, Holland. (IWM CL1589)

Rocket projectile Typhoon aircraft of the RAF lined up 'on a landing strip somewhere in Northern France', subsequently identified as B5, Le Fresne Camilly. (IWM CL154)

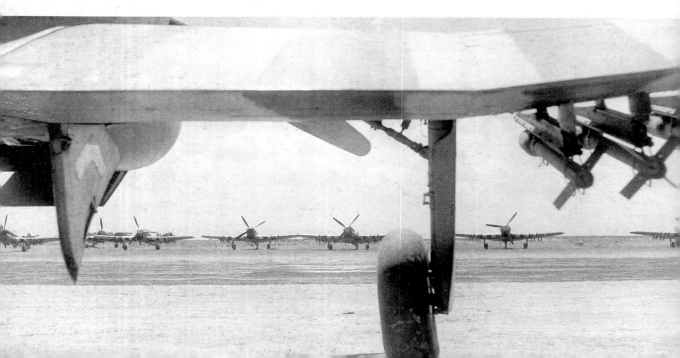

A Royal Air Force North American Mustang Mk. I of the 2nd Tactical Air Force flies over a convoy of Allied tanks heading inland from the coast near Conde-sur-Noireau.

Designed from the outset to meet RAF requirements, the Mustang with its original Allison engine displayed poor performance at altitude. It was therefore decided to limit the Mustang to lower level armed tactical reconnaissance (Tac/R). The Mustang had a large camera fitted in the fuselage behind the pilot which shot photographs through a clear covered aperture on the port side of the aircraft, possibly explaining the attitude of the Mustang pictured.

Although all Allied tactical aircraft had D-Day stripes, many of the RAF's tactical reconnaissance Mustangs did not apply stripes on the upper surfaces of the wings. Because of the type of work they did at very low altitudes, pilots did not wish to undermine the effectiveness of their sometimes much-needed camouflage. RAF tactical reconnaissance units suffered high losses in the weeks after D-Day, mostly due to ground fire from German troops. The information they gathered on their high-risk missions ensured that Allied leaders were aware of threats from the enemy and opportunities for advances. (IWM C4559)

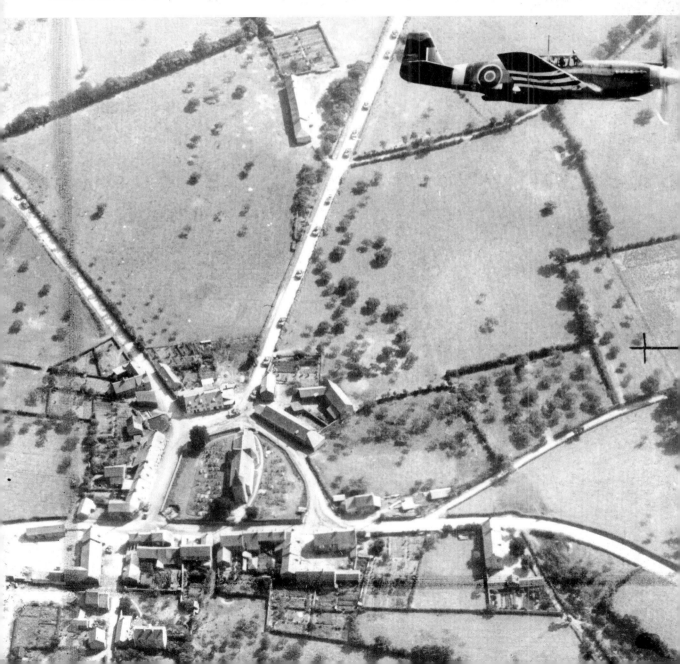

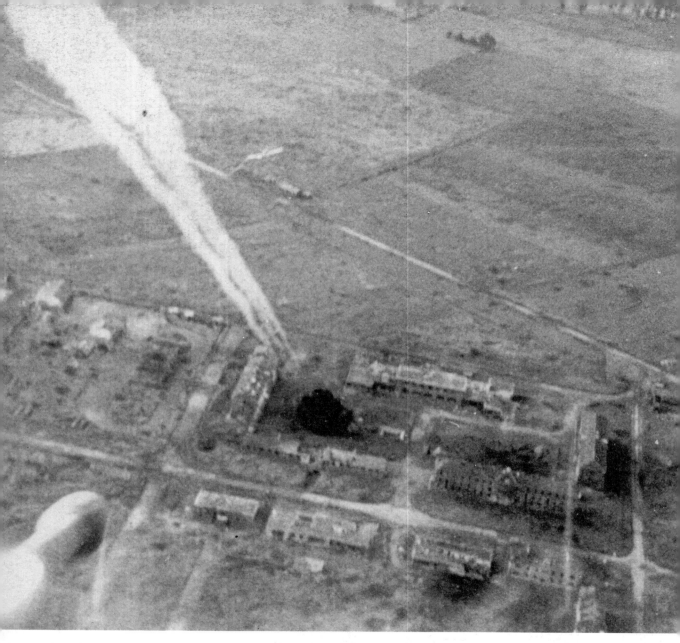

A rocket from a Royal Air Force Hawker Typhoon on its way to buildings at Carpiquet airfield west of Caen. Carpiquet village and the nearby airfield were objectives for the 3rd Canadian Division on D-Day. However, it was not until early July that Canadian troops finally captured the area after a violent battle with the 12th SS Division. Operation Windsor was launched on 4 July 1944 and it became known to the Canadians that fought in it as the Battle of Carpiquet.

At Carpiquet village, the North Shores regiment and the Chaudieres fought a fierce guerilla-style battle against the defenders and lost 40 men on the first day. On the opposite side of the airfield, the Winnipeg Rifles encountered pillboxes and concrete bunkers which enabled the Germans to rake the area around. At night, the Canadians based in Carpiquet were inundated with mortar and artillery fire. A company of Chaudieres was overrun by the German defenders on an offensive, some of them later to be found bound, shot and buried.

On 9 July, some thirty-three days after the Allied landings, Carpiquet airfield was taken. (IWM C4460)

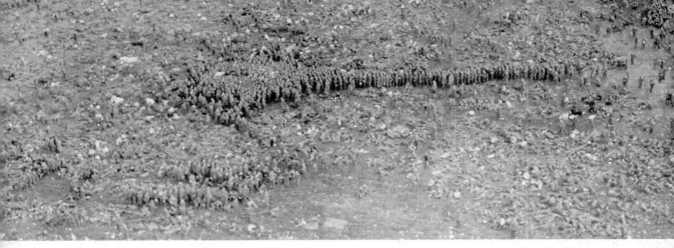

An aerial view of more than 10,000 German prisoners of war waiting in a large PoW stockade awaiting transportation to camps in the rear. All were trapped in the Falaise pocket. (IWM EA34516)

RAF ground-crew battling against the clock to refuel a Spitfire in a front-line landing strip. The fuel was poured into the aircraft's fuel tank via the square sieve that can be seen being held above the engine cowling. It was heavy work heaving the fuel laden jerry-cans onto the wing but it was the only method available in the early days of the invasion. This aircraft is a Spitfire Mk IX, powered by a Rolls-Royce Merlin 61 engine. One of its two 20mm cannons can be seen on the starboard wing on the left of the photograph. The Mk IX was designed to take on the infamous German Focke Wulf Fw 190 that had been superior to previous marks. (IWM CL76)

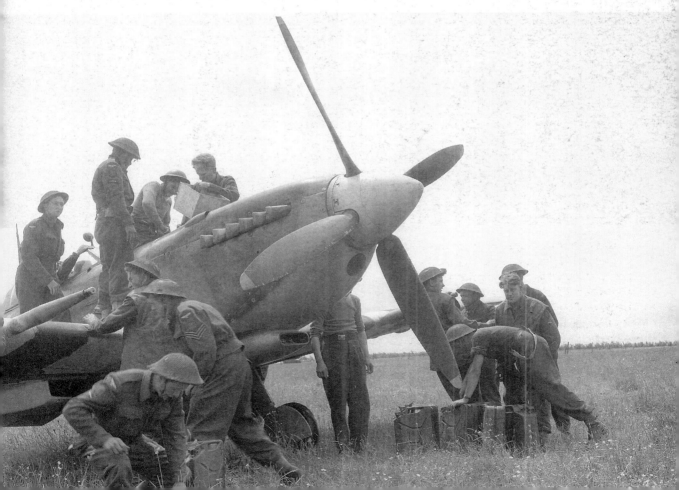

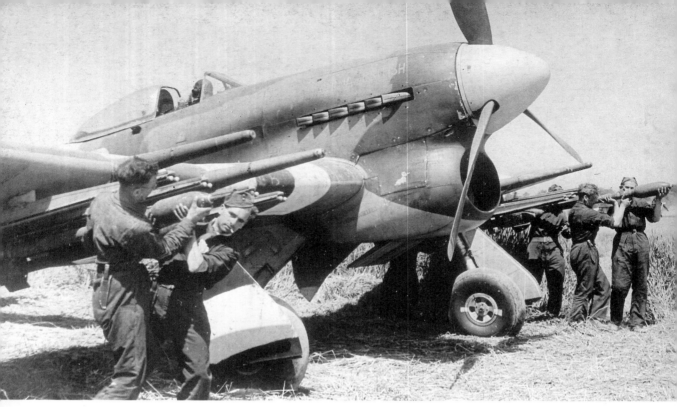

RAF ground crews bombing up a Hawker Typhoon with rocket projectiles on an airstrip in France. The rockets positioned under the wings of the aircraft were essentially a more advanced version of a skyrocket firework. Solid fuel propellant was packed into a three inch diameter pipe with a 60 lb warhead attached, which could be armour-piercing, semi-armour piercing, or high explosive 'shot'. The rockets could be fired in pairs, fours, or in a ripple salvo. Later trials confirmed that two tiers of four could be carried under each wing. The noise and destruction caused by 16 such weapons, each with a 60 lb warhead, must have been fearsome. (IWM CL157)

Two Royal Air Force medical officers, Flt. Lt. W. L. Hardman of Grange-over-Sands, Lancashire, and Sqn. Ldr. A. Davies of Brondesbury, London, have taken their wireless set to the edge of their orchard camp. French villagers and refugees from the Caen area lean over the wall to listen to the news in French broadcast from London by the BBC. The RAF men were from an RAF airstrip from which Mustangs operated. (IWM CL262)

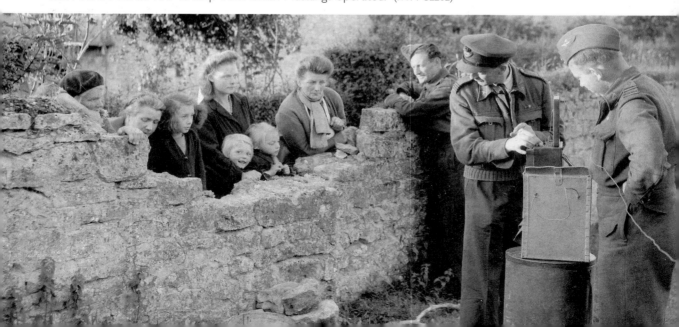

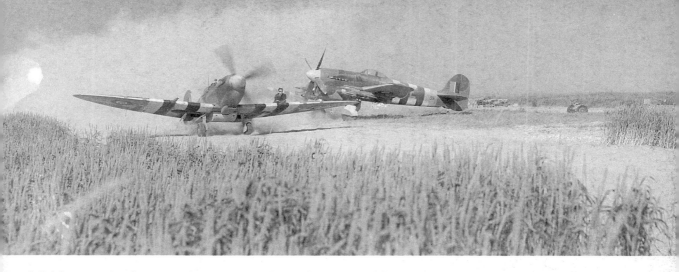

A Spitfire returning from a sortie over enemy lines in France, taxies from the runway to dispersal, passing a parked Typhoon en route. Note the airman lying on the port wing to guide the pilot along the dusty track. The Spitfire, like many tail-wheeled aircraft, gave the pilot no forward vision whilst on the ground. Because of the clouds of dust stirred up by the aircraft the units referred to themselves as the Dust Rats. (IWM CL182)

A group of Royal Air Force Servicing Commandos rest in their outdoor workshop in a cornfield. They are wearing anti-gas goggles to protect their eyes from the dust clouds stirred up by aircraft landing and taking off. Although the dust cloud was visible from some distance away, there was no danger of enemy attack, since nothing was visible on the ground such was the density of the dust. (IWM CL149)

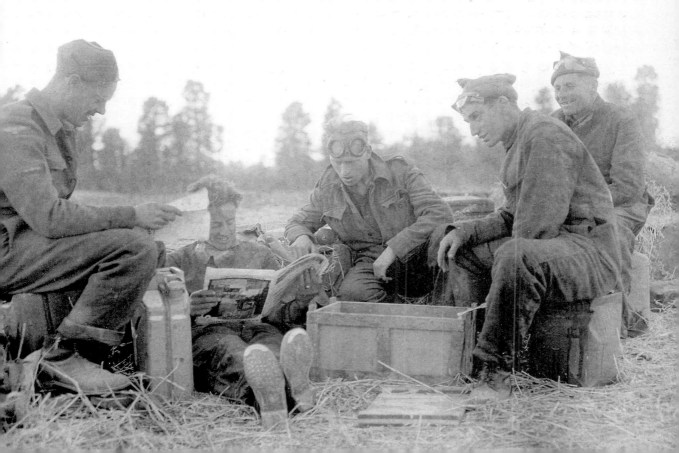

Corporal J. Coxall of Wembley, London, fitting electric leads to rocket projectiles destined for use by RAF Typhoons. The Rocket Projectile (or RP, or rocket) was developed in the early 1940s as a new weapon for attacking ground and naval targets. It was essentially a length of three inch (75 mm) diameter steel tube, about six feet (2 metres) long, filled with cordite.

At the tail end, fins ensured a straight flight. A firing cap was fitted with a plug which hung down, known as the pigtail, which fitted into a socket under the wing of the aircraft. When the button was pressed by the pilot in the cockpit, an electric charge ignited the firing cap causing the cordite to burn, and generate the thrust to carry the rocket forward and free from its rail. There were three types of head used in combat, a 25 lb armour-piercing head, a 25 lb semi-armour-piercing head, and a 60 lb (27 kg) high-explosive head. Later, 90 lb (41 kg) heads were developed. (IWM CL148)

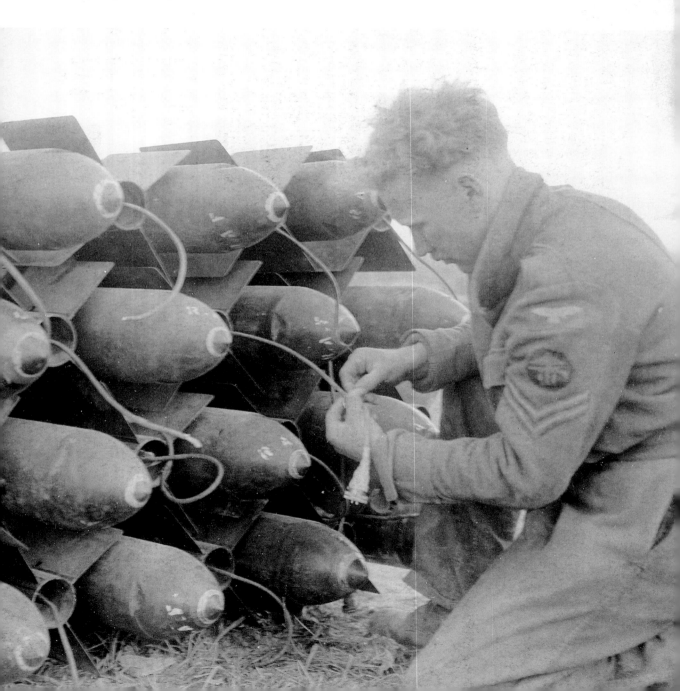

Major-General Joseph I. Collins, commander of the US 7th Corps which liberated Cherbourg, with a party of his officers atop the fort overlooking the city and harbour shortly after its fall, 27 June 1944. Smoke rises from burning port facilities in the background. The Americans found that the Germans had destroyed much of the port before General Schlieben ordered the surrender of his formidable 40,000 strong garrison. It would be some time before the port was operational again. (IWM EA38531)

Royal Air Force ground crews on an airstrip in Normandy write letters home and chat. They are using empty petrol jerry-cans as seats. Note that the third airman from the left has a war trophy in his lap. The aircraft in the background is a Hawker Hurricane, complete with D-Day invasion stripes. (IWM CL77)

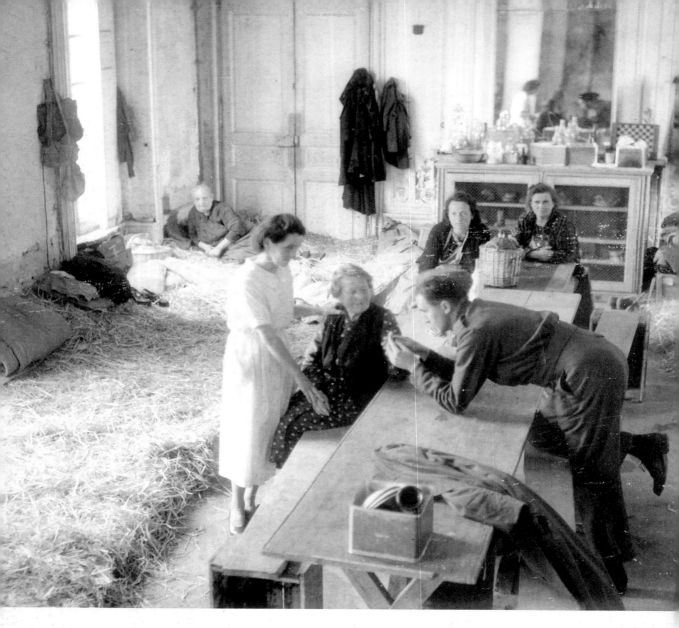

A Royal Air Force Officer pictured with displaced French civilians in an abandoned Normandy chateau. The evident former elegance of the building is in stark contrast with the plight of the civilians who had to leave their homes swiftly and with few personal belongings. The purpose of the straw floor covering is clear as the elderly lady in the corner shows. As the Allies fought and won control of Normandy piece by piece, many displaced civilians returned to their homes. Some found their properties intact while others found their houses had been looted or obliterated by bombing. (IWM CL335)

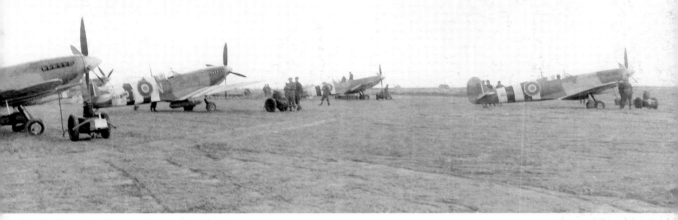

Spitfire Mk IXs of No 443 Squadron (Canadian). This squadron was one of the first RAF units to be based in France, being part 144 Wing, 83 Group, 2nd Tactical Air Force. The Wing was lead by the legendary Wing Commander J. E. (Johnnie) Johnson and accounted for many Luftwaffe FW 100s and Bf 109s soon after the landings when they were based at St. Croix-sur-Mer. After the landings 83 Group concentrated on giving air cover over the forward troops as they moved inland. (IWM CL87)

This is the carpenters' shop of a Royal Air Force Repair and Salvage unit. In the background can be seen a Spitfire. The men featured are left to right, Leading Aircraftman L.E. Mireau of Saskatoon, Saskatchewan, Corporal K.R. Rowbeery of Qunton, Birmingham and Leading Aircraftman L.B. Steele of Lochwinnoch, Glasgow. (IWM CL194)

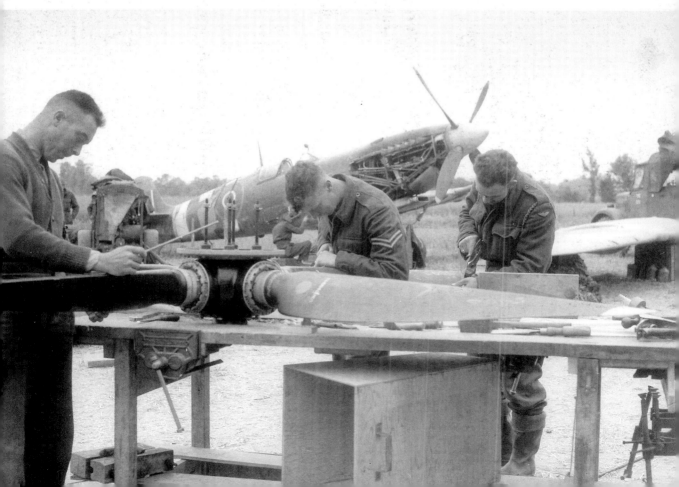

RAF and Royal Canadian Air Force personnel take a break between sorties (note the Mae West lifejacket and map stuffed in the boot of the pilot on the right) to fraternise with welcoming local residents. Farms were able to provide fresh provisions such as eggs which made a welcome break from the fare produced by the field kitchens at Allied airfields early in the Normandy campaign. (IWM CL263)

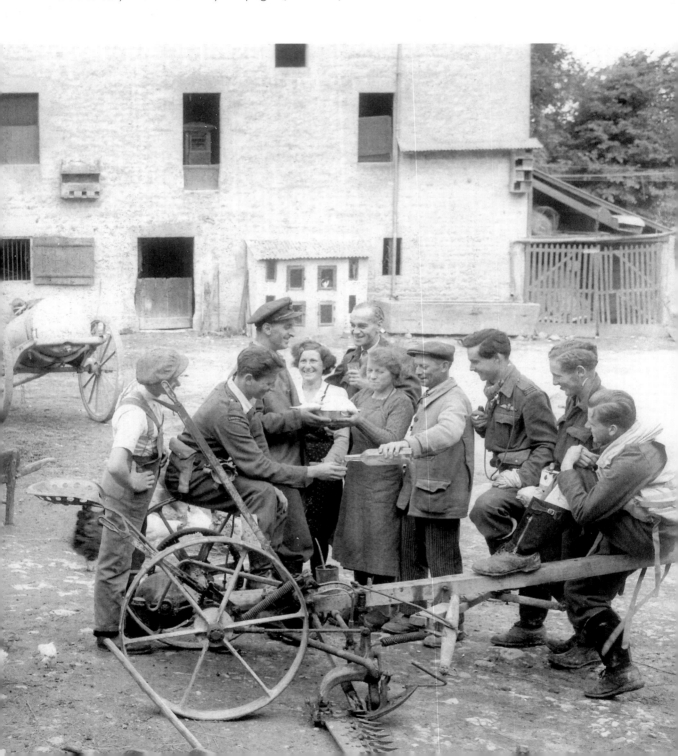

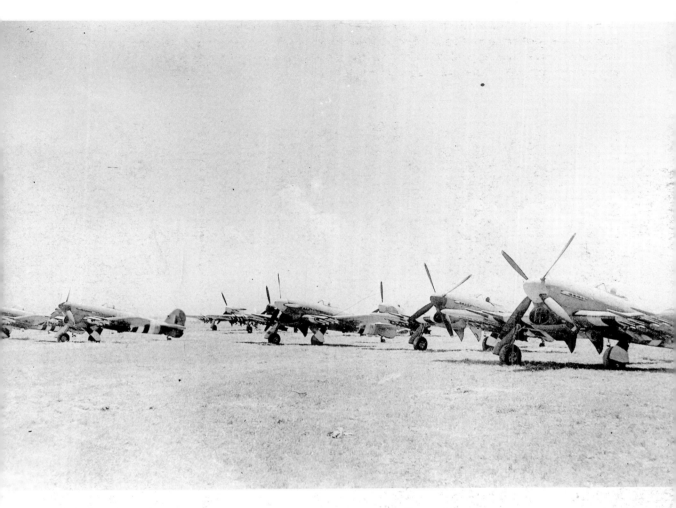

The official wartime caption for this read 'Photograph taken on one of the landing strips in France where Allied planes covering the landings can land for refuelling, repairs etc.' Subsequently the rocket-armed Typhoon aircraft have been identified as being from No.175 Squadron, 121 Wing and the airstrip is thought to be Le Fresne Camilly, also known as B5. (IWM CL153)

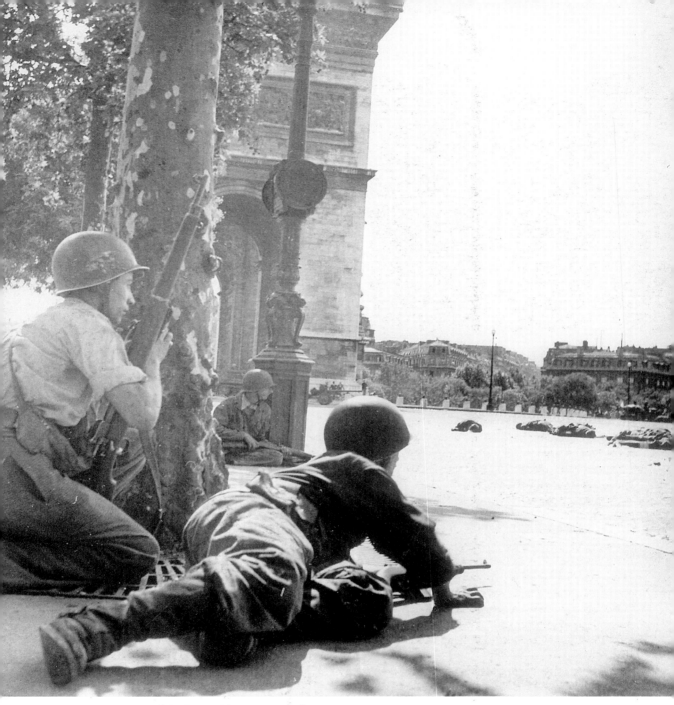

In the shadow of the Arc de Triomphe, two soldiers of the 2nd French Armoured Division shoot at Nazi snipers and pro-Nazi French militia who were making an abortive attempt to free German prisoners. The latter lie dead on the Champs Elysees. (IWM EA37079)

General Montgomery, Commander in Chief Land Forces, talks to civilians following their liberation. On the eve of D-Day, Monty sent all the troops under his command a personal copy of the following message:

'The time has come to deal the enemy a terrific blow in Western Europe. The blow will be struck by the combined Sea, Land and Air Forces of the Allies – together constituting one great allied team under the supreme command of General Eisenhower.

On the eve of this great adventure I send my best wishes to every soldier in the Allied team. To us is given the honour of striking a blow for freedom which will live in history; and in the better days that lie ahead men will speak with pride of our doings. We have a great and righteous cause. Let us pray that the "Lord Mighty in Battle" will go forth with our armies and that his special providence will aid us in the struggle.

I want every soldier to know that I have complete confidence in the successful outcome of the operations that are about to begin. With stout hearts and with enthusiasm for the contest let us go forward to victory. And as we enter the battle let us recall the words of a famous soldier spoken many years ago:

 "He that fears his fate too much,
 Or his deserts are small,
 Who dare not put it to the touch,
 To win or lose it all."

Good luck to each one of you, and good hunting on the mainland of Europe.' (IWM B5318)

Fifty-three year old General Dwight D. (David) Eisenhower, pictured here during a five-day tour of the Normandy front, was the Supreme Allied Commander in overall charge of the D-Day landings and subsequent campaigns. While commanding ground forces in Italy following its invasion, he was recalled to London in December 1943 to take command of the forces that prepared for the invasion of France. As Commander of SHAEF (Supreme Headquarters Allied Expeditionary Force), Eisenhower had to knit Allied armies, navies and air forces together to build the greatest invading force ever assembled. His general staff, assisting him with the task, amounted to around 16,000 men and officers.

In 1953, 'Ike' became the Thirty-Fourth President of the United States of America and in 1956 was re-elected for a second term. (IWM NYP31355)

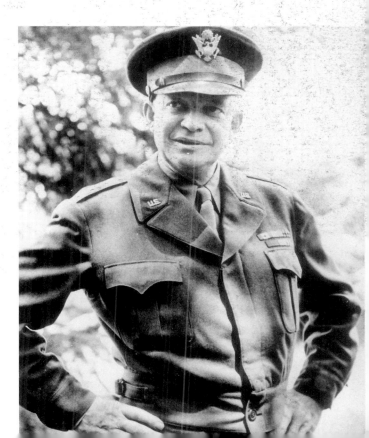

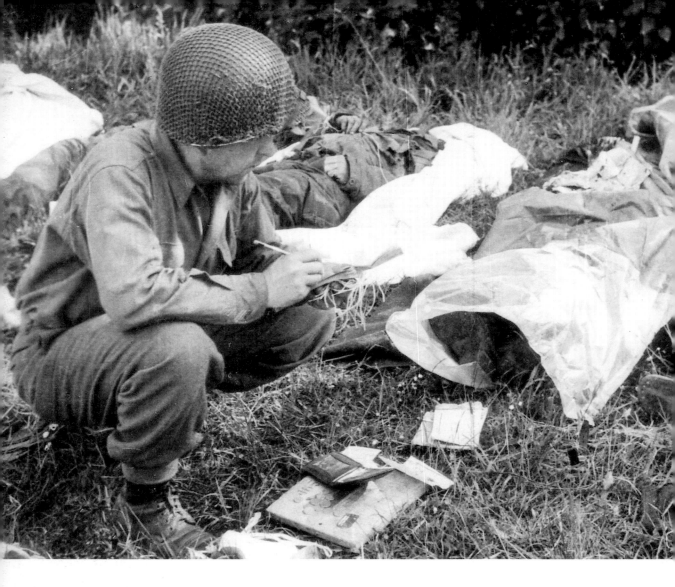

The final act. A US sergeant checks the personal effects and removes a dog tag from the lifeless remains of a D-Day victim before the burial parties begin their work. The main US military cemetery for Normandy was established close to St.-Mere-Eglise. After the war, the remains were re-interred on the cliffs, forming the US National Cemetery overlooking Omaha Beach. (USA10351)